Richard Deacon
Personals

IKON

This Is Not Another Story, 2005
Resin bricks
6 x 19 x 9 cm (x 100)

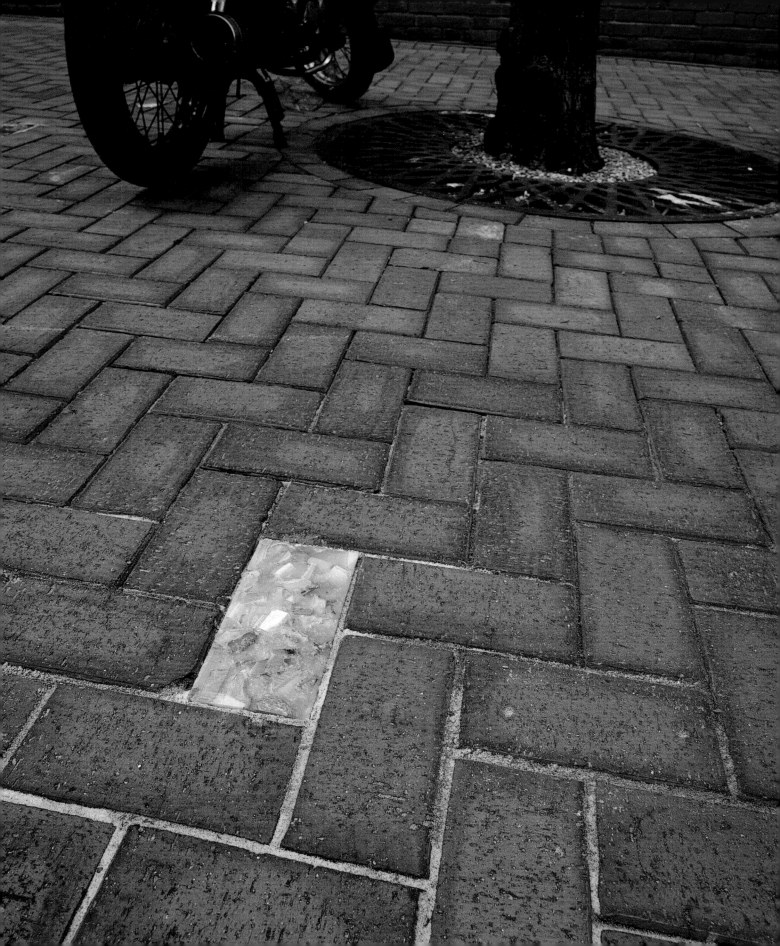

Foreword

This exhibition, a combination of new and recent works by Richard Deacon, never before shown in the UK, characteristically tests the definition of sculpture. It is playful in its radical propositions about art and life, revealing the artist as pre-eminent amongst his contemporaries, inventive in the extreme.

Being part of an artistic generation that continued to assert the relevance of sculpture through the heyday of conceptualism and the subsequent emergence of postmodernism, Deacon makes work that is disarmingly straightforward. At the same time it embodies a smart knowingness. He acknowledges the tradition of his art form – sometimes alluding to the work of other artists – but is not hidebound by it. He communicates an optimistic scepticism, the enjoyment of an aesthetic freedom that is based on the understanding that art can be made out of anything, deriving its identity and meaning through its context, audiences and milieu as much as physical environment. Certainly this is an artist who is not so concerned so much with privileging artistic experience; rather he is encouraging a closer scrutiny of everything, art and non-artistic phenomena alike.

Deacon's use of readymades (or 'found objects') in this exhibition is significant, as objects not intended for artistic experience find themselves in a dedicated art space. *Display Table* consists of a table on which the artist has put some small objects, an assortment of tree roots, fossils and rocks, as if they were part of some natural history display. They have the appearance of specimens singled out for contemplation – not unlike special rocks and stones in oriental culture – but in fact they are the kinds of things that anyone could pick up while gardening or taking a walk in the country. They are like billions of similar objects available in the world beyond the gallery, just happening on this occasion to be considered as art.

Deacon is making an interesting reference to Henry Moore, in particular Moore's habit of collecting little flint stones found in the landscape around his studio that often provided the inspiration for his works. For Deacon, like Duchamp, found objects can be perfectly at home in the gallery; but, unlike Duchamp, Deacon tends to choose objects that are not manufactured, not man-made. This exemplifies his longstanding interest in natural forms – geological, biomorphic and so on – and other works in this exhibition likewise suggest such organic and inorganic matter. *It's A Small World*, for example, is a series of miniature ceramic pieces resembling shellfish, worm-moulds, bivalves and other primitive life-forms, crystal formations and so on. Arranged on a large table in the middle of a gallery, like an island, it is

as if we have a bird's eye view of the infinite variety that constitutes wonderful life.

A number of larger ceramic sculptures in the exhibition have more geometric quality, but this is counteracted to some extent by the tubular lengths bent and irregularly joined, covered with a dripping, shiny glaze. Each piece is in fact the result of two open forms conjoined in what the artist refers to as a 'Siamese' way so that they are mutually dependent structurally, each appearing to be pushed into the other. These sculptures correspond to a series of drawings that explore similar aesthetic territory in two dimensions. Twenty-six in all, Deacon refers to them as an 'alphabet', as if they were basic signs in a visual language. The idea of pure abstraction, whereby the work of art signifies nothing but itself – an art for art's sake – is contradicted through an idea of countless combinations of these letters into words and sentences and so on, into a code perhaps that could be interpreted.

Personal interpretations of attempts at communication are crucial for our understanding of Deacon's works, epitomised here by an archive of newspapers, selected by the artist and members of his family since the beginning of the last century. Front pages announce important historical and political events, framed and in chronological order. Here is an announcement of India's Independence, Kennedy's Assassination, The Funeral of King George VI, Churchill's Death, The Harrow Train Crash and the moonlanding of Apollo 11 as reported in newspapers from all over the world, read by a British family, saved for very personal reasons. The regularity of the presentation belies idiosyncrasy, and autobiography, the way that our lives collide with current affairs. Entitled *In My Father's House* there are lots of stories to be read literally and in between the lines. Likewise, there are stories in the abstract sculptures, the alphabet drawings, the found objects that are more than simply 'found'. In short, Richard Deacon is restless with received wisdom, always complicating what we think we know.

There is a generous spirit that pervades this exhibition, encouraging openness and benefit of the doubt in the best sense. It is very much in keeping with the support we have enjoyed from a range of individuals and organisations towards the realisation of our plans. We are very grateful to Brindleyplace, Esmée Fairbairn Foundation, Thomas Stanley Johnson Foundation and The Henry Moore Foundation for their goodwill and practical help. Matthew Perry, for his technical genius, and Penelope Curtis, for her intelligent writing, have enhanced this project enormously. Above all, thanks to Richard Deacon for his extraordinary vision.

Jonathan Watkins, Director

next page
Some Interference, 2007
Wall drawing, felt tip pen
115 x 150 cm

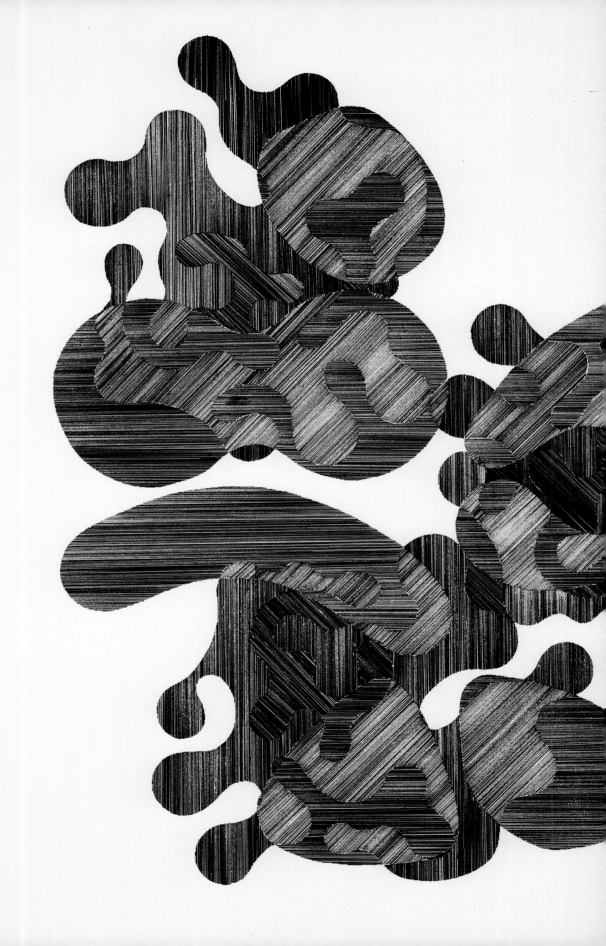

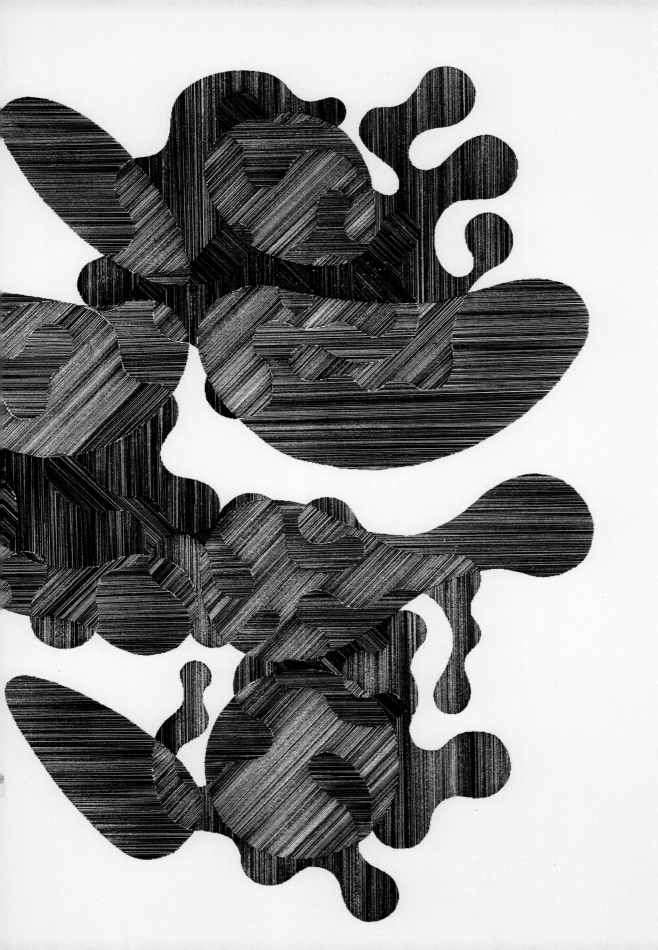

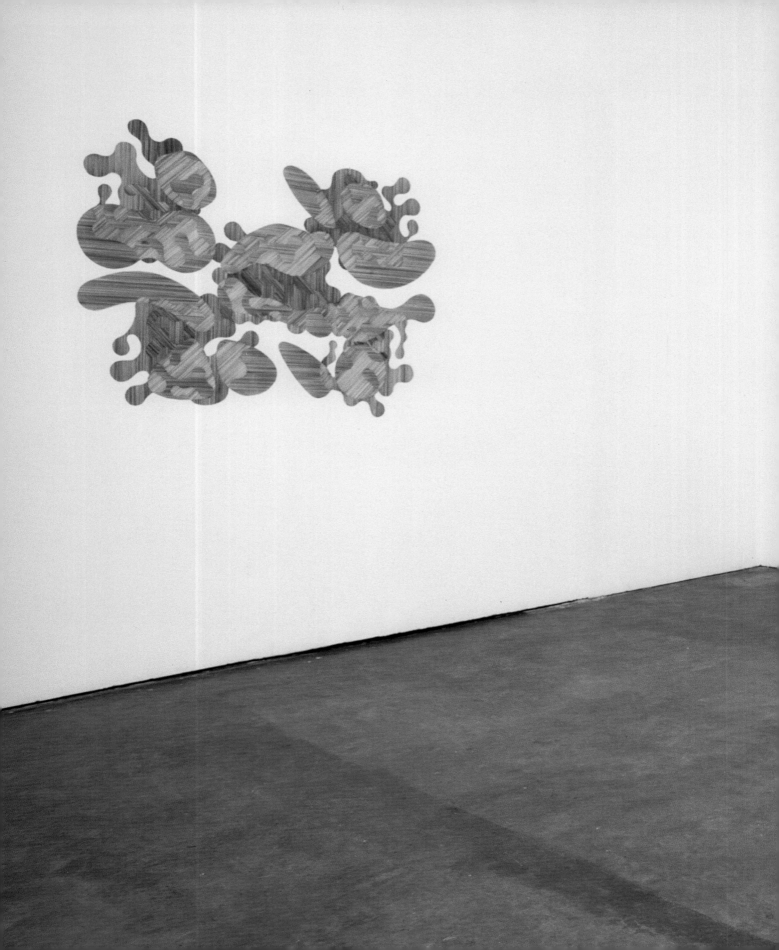

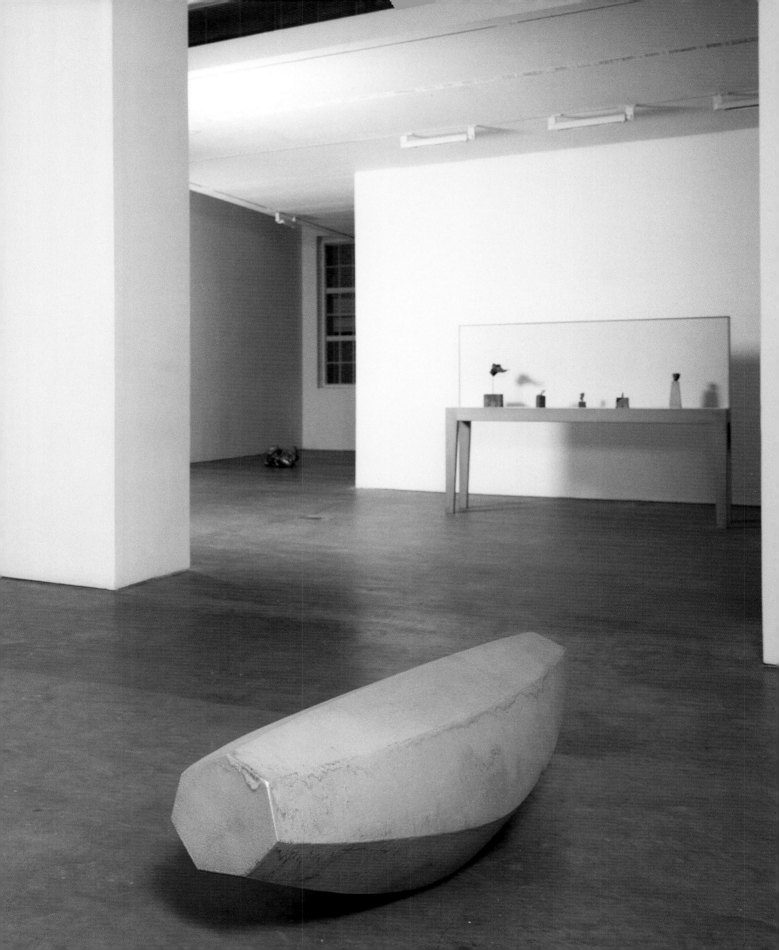

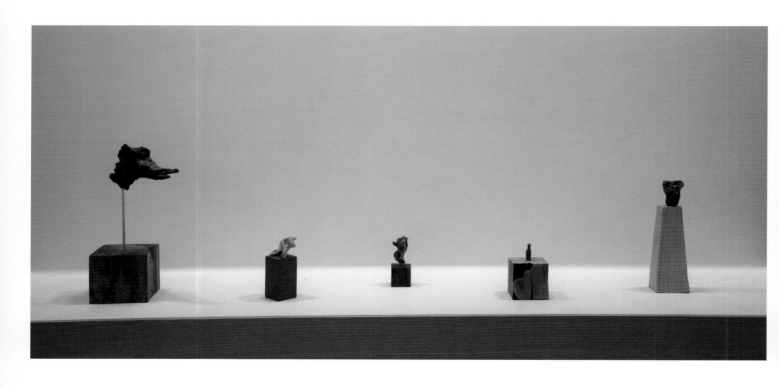

Display Table, 2004
5 objects and supports with table
180 x 220 x 54 cm

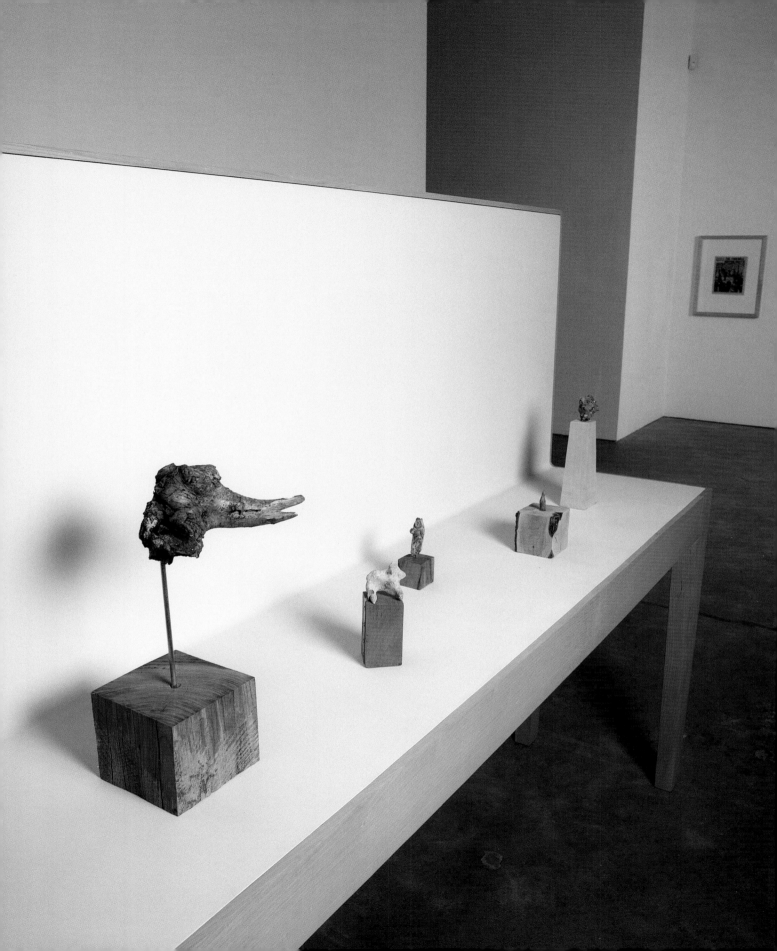

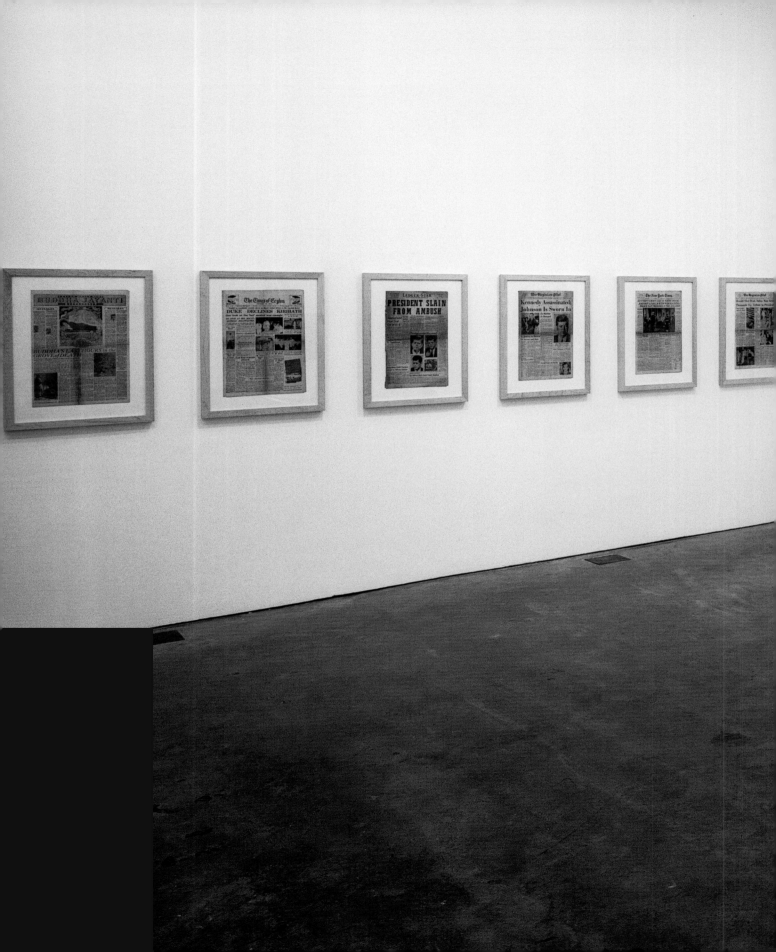

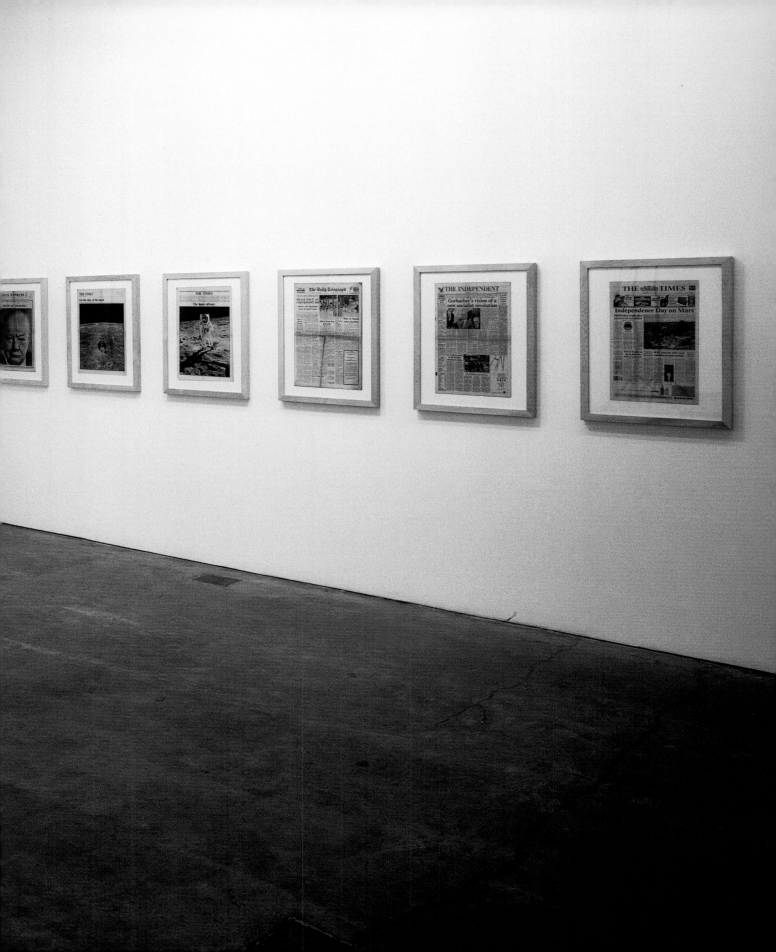

In My Father's House, 2006
Framed newspapers
76 x 60 cm (x 28)

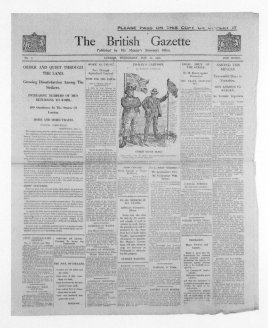
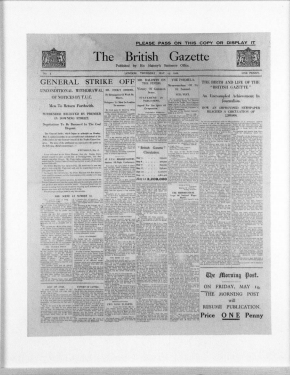
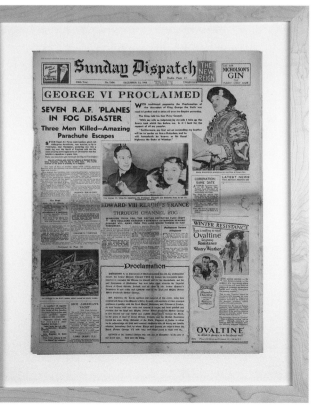

Daily Record
7000 Scots at Royal garden party
A link with Elizabeth I

THE BOURNEMOUTH TIMES & DIRECTORY
IT'S NEARLY ALWAYS NO FROM WHITEHALL
Roads unmade for 30 years

The Press and Journal
AMERICAN JETS BOMB GREEKS IN MISTAKE
Queen Mother at Beauly Church
Gen. Neguib at War With the Wafd Party

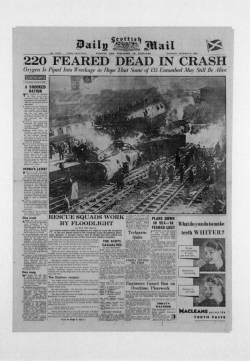

Daily Scottish Mail
220 FEARED DEAD IN CRASH
Oxygen Is Piped Into Wreckage in Hope That Some of 135 Entombed May Still Be Alive

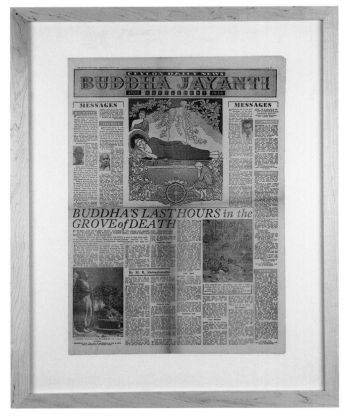

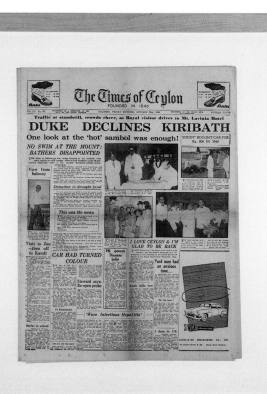

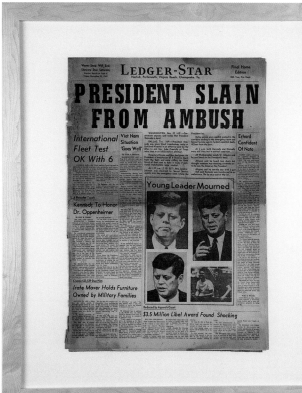

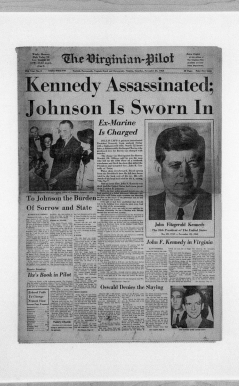

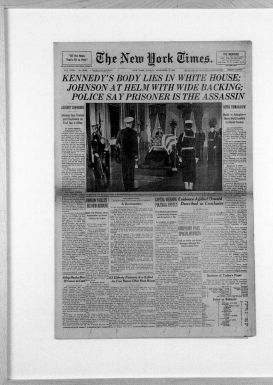

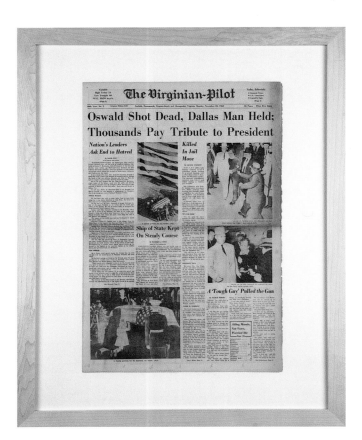

The Virginian-Pilot

Oswald Shot Dead, Dallas Man Held; Thousands Pay Tribute to President

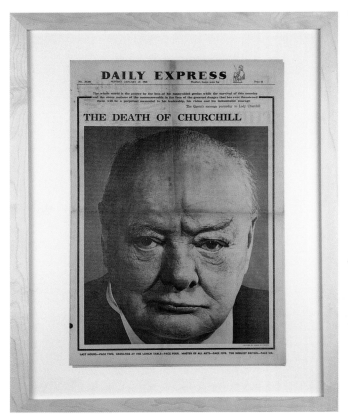

DAILY EXPRESS

THE DEATH OF CHURCHILL

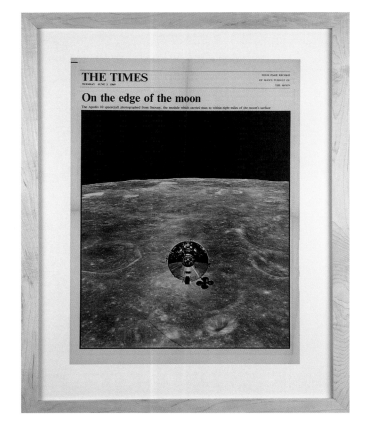

THE TIMES

On the edge of the moon

The Apollo 10 spacecraft photographed from Snoopy, the module which carried man to within eight miles of the moon's surface

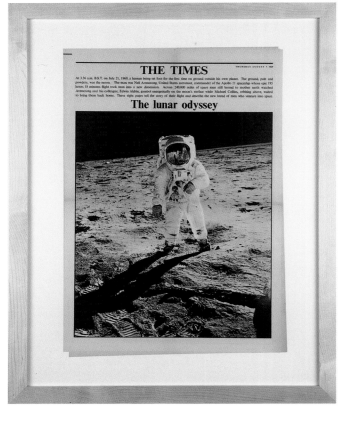

THE TIMES

The lunar odyssey

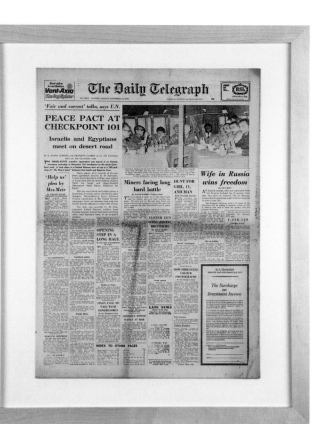

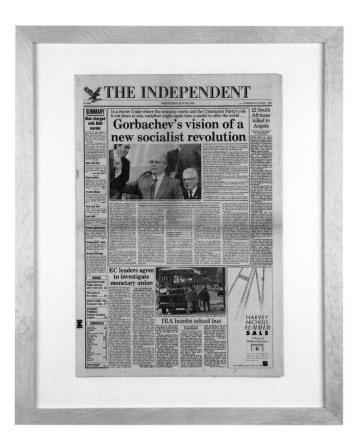

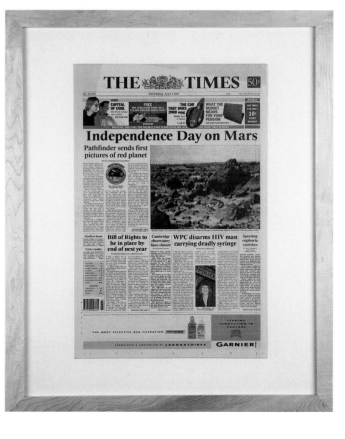

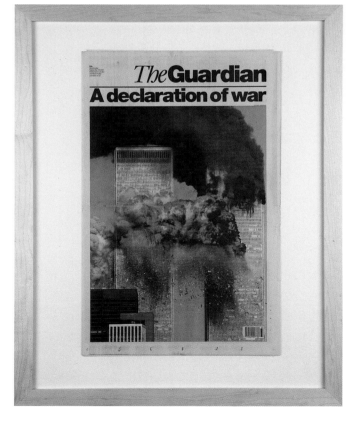

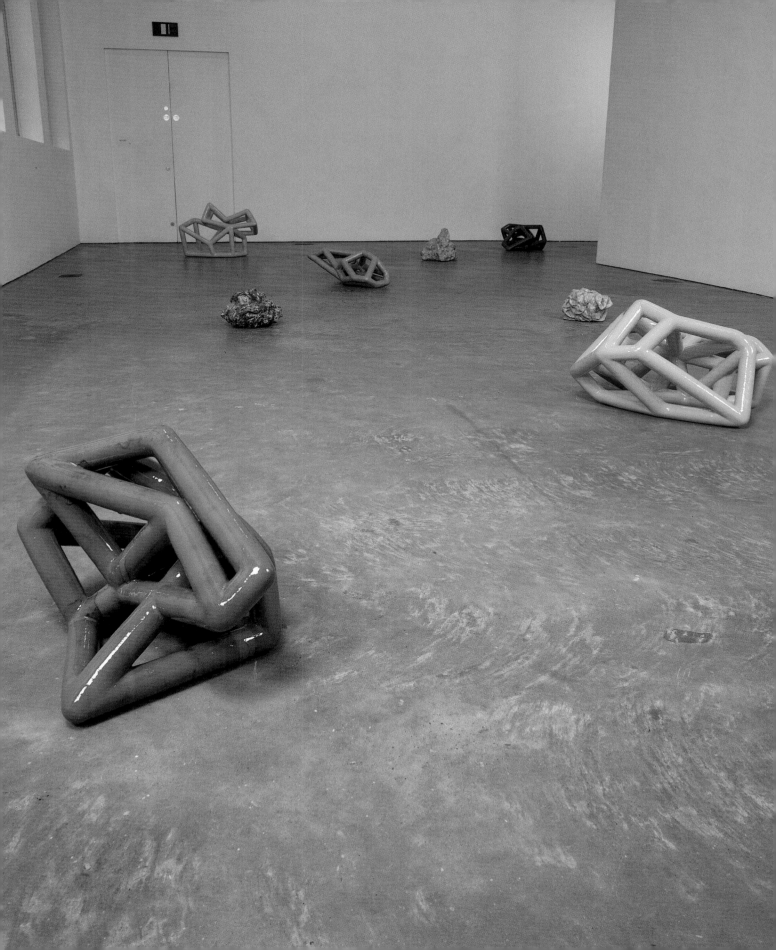

Siamese Green, 2006
Ceramic sculpture
37 x 55 x 40 cm

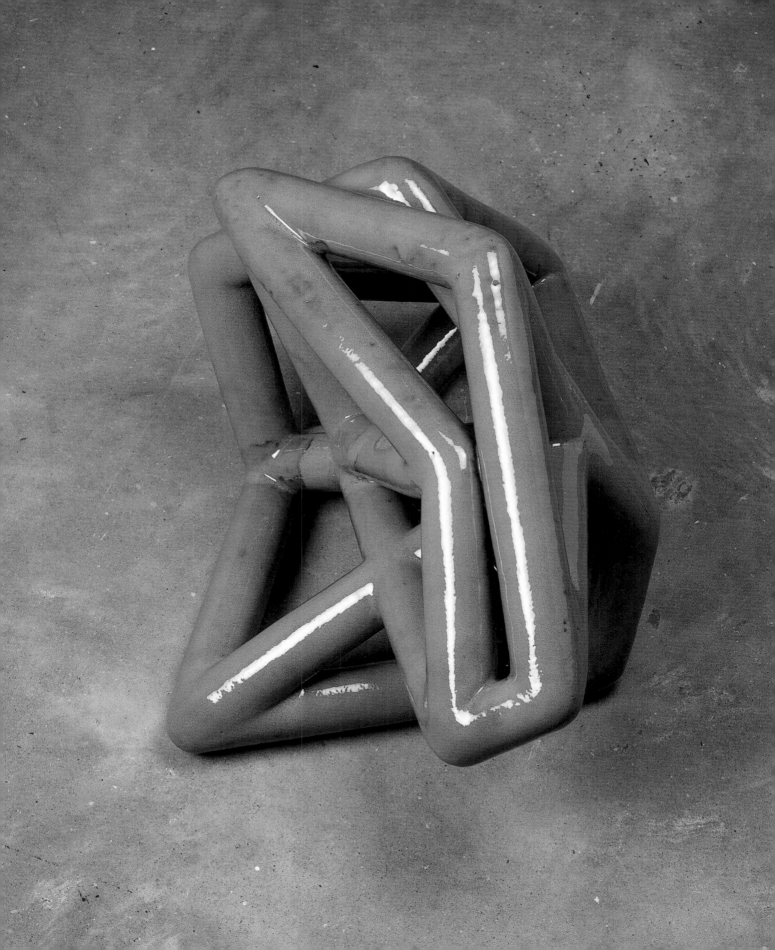

North 5, 2006
Glazed (green/brown)
34 x 48 x 53 cm

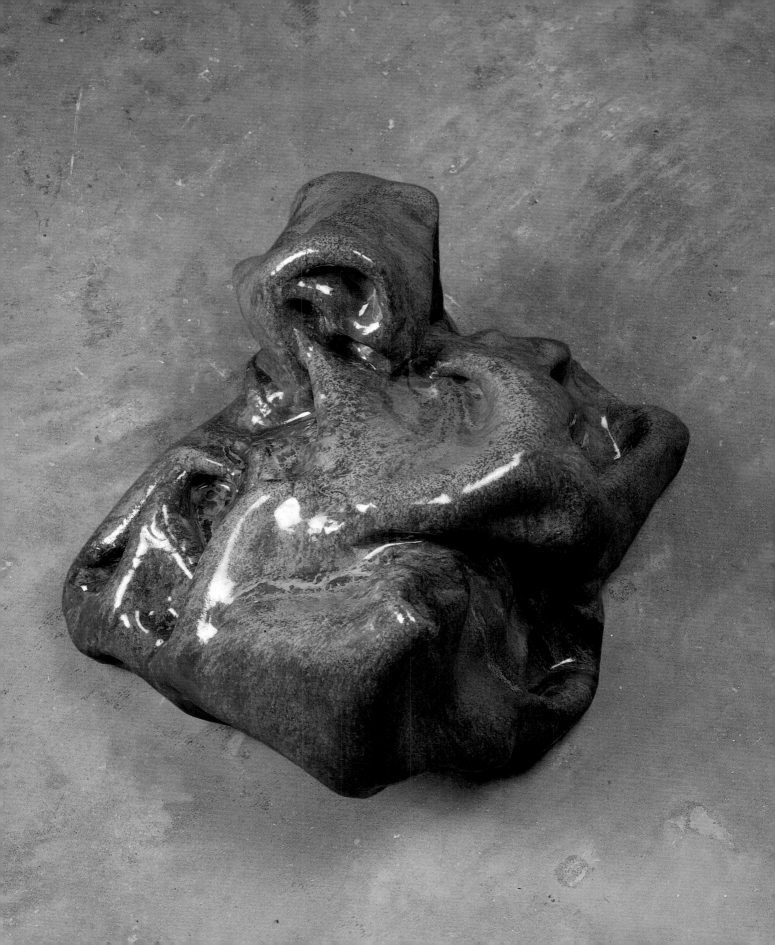

Siamese Pink, 2006
Ceramic sculpture
40 x 69 x 59 cm

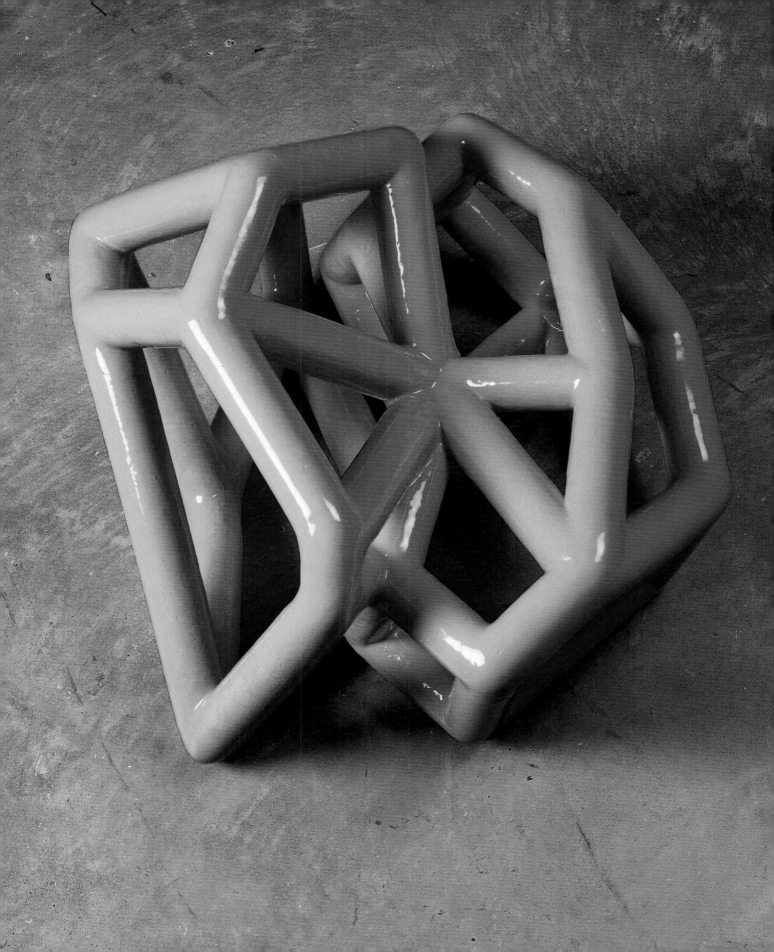

North 2, 2006
Glazed (green/light green)
20 x 30 x 25 cm

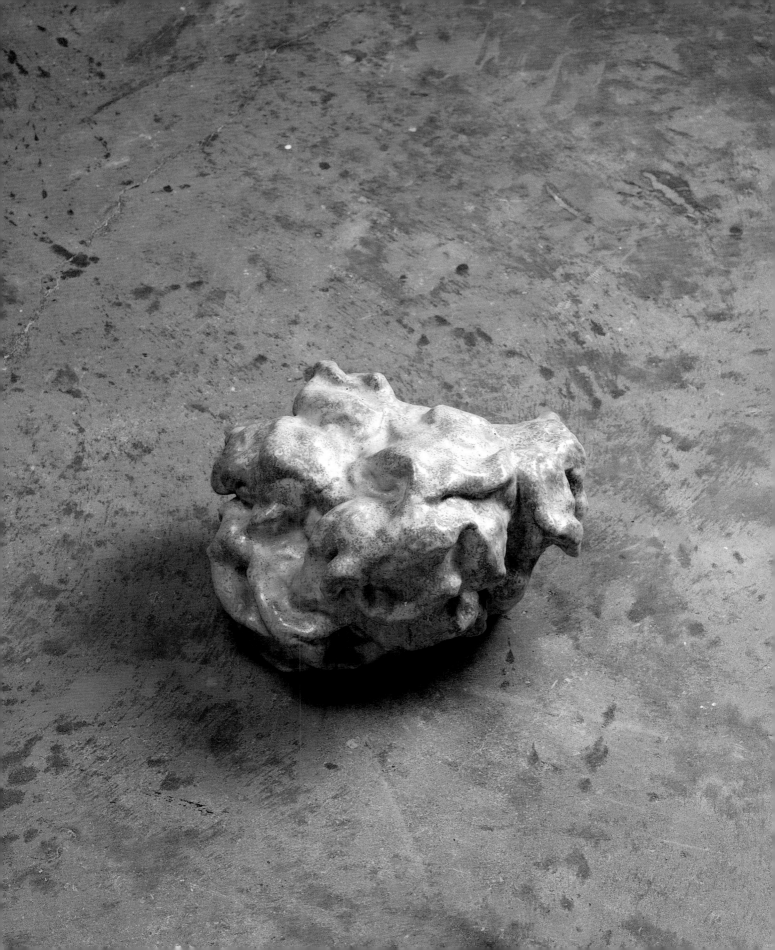

North 4, 2006
Glazed (black/white/red)
21 x 32 x 27 cm

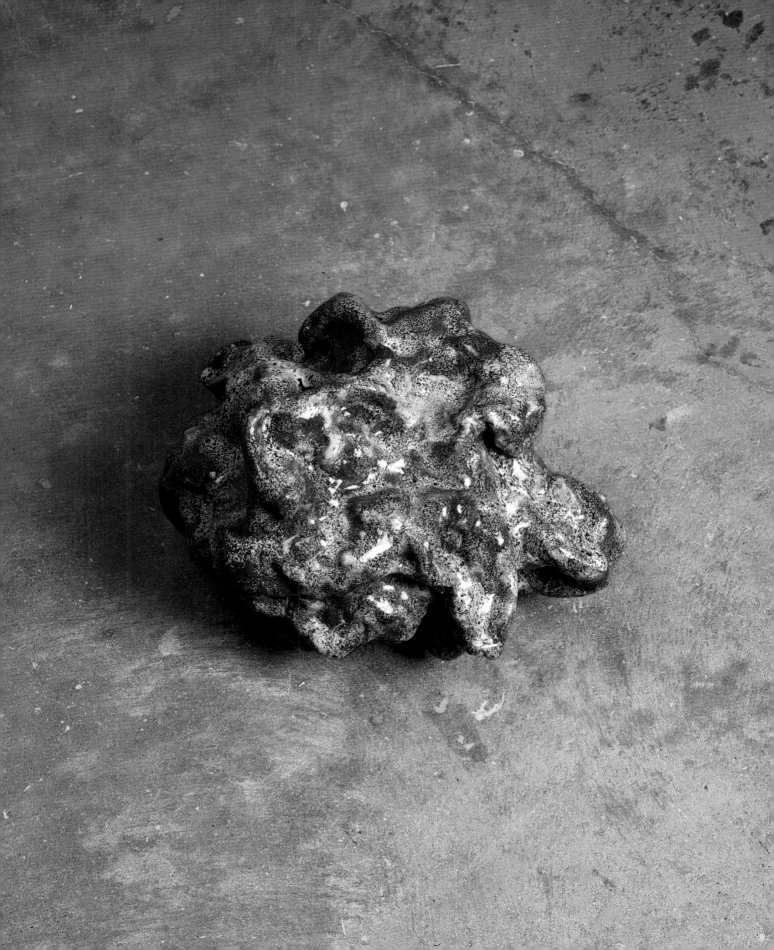

Siamese Lustrous, 2006
Ceramic sculpture
28 x 78 x 38 cm

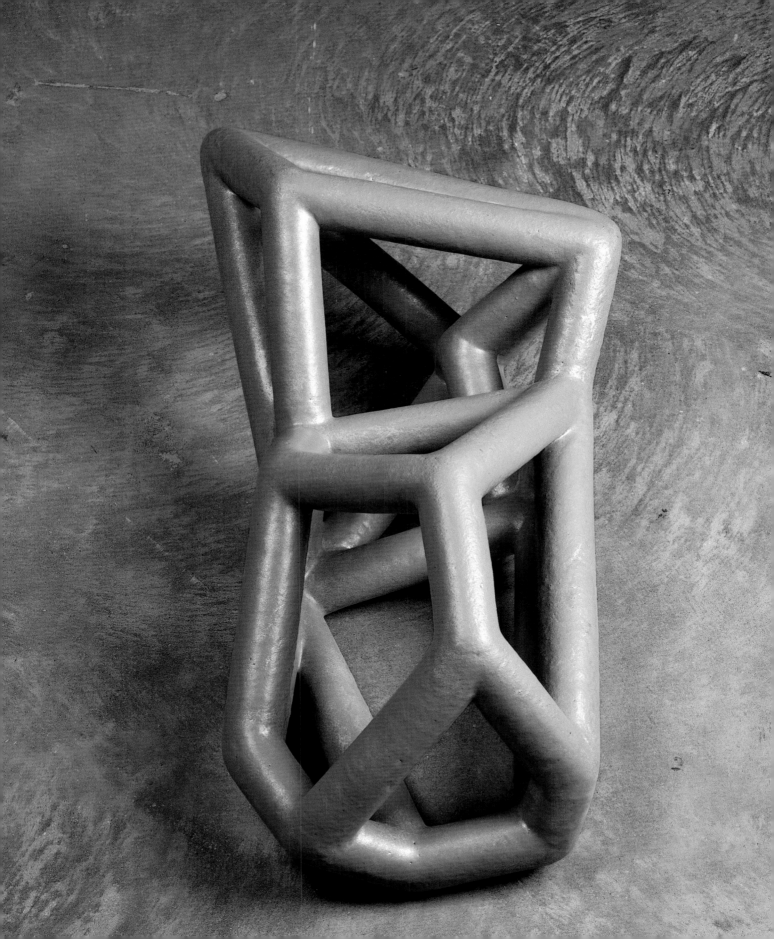

North 6, 2006
Glazed (grey/white)
33 x 51 x 41 cm

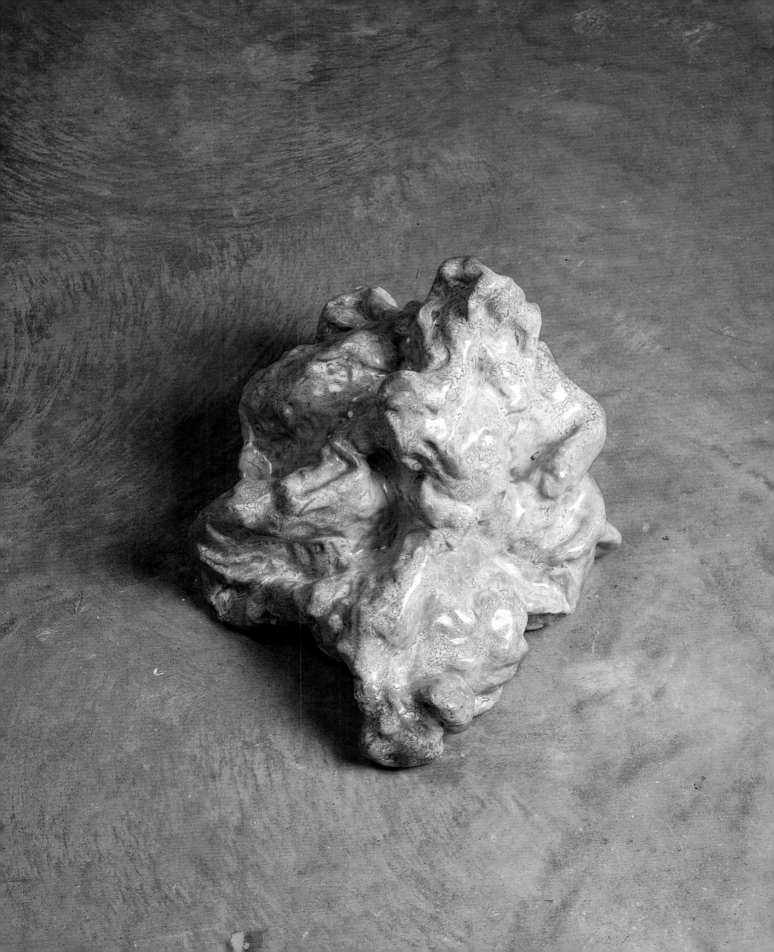

Siamese Yellow, 2006
Ceramic sculpture
57 x 84 x 40 cm

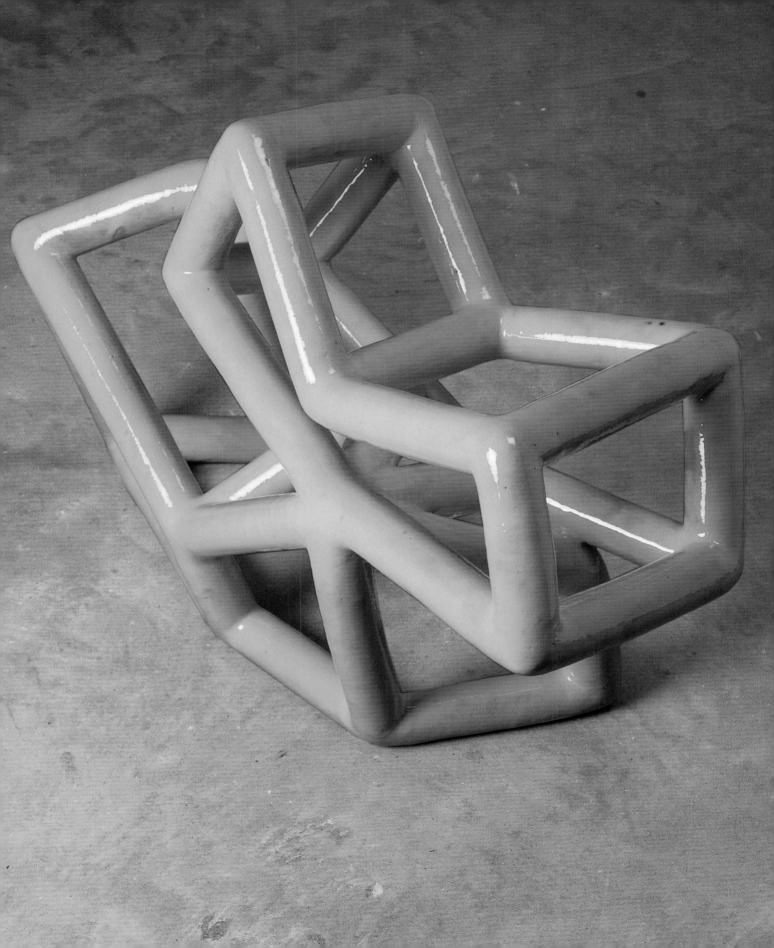

Siamese Snakeskin, 2006
Ceramic sculpture
31.5 x 60 x 60 cm

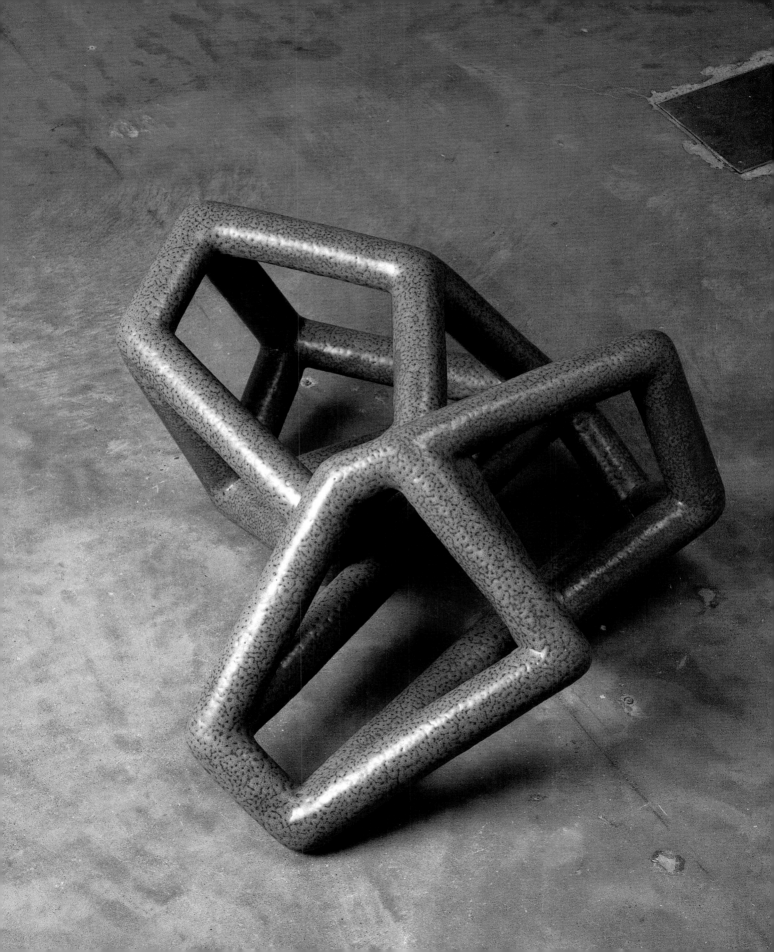

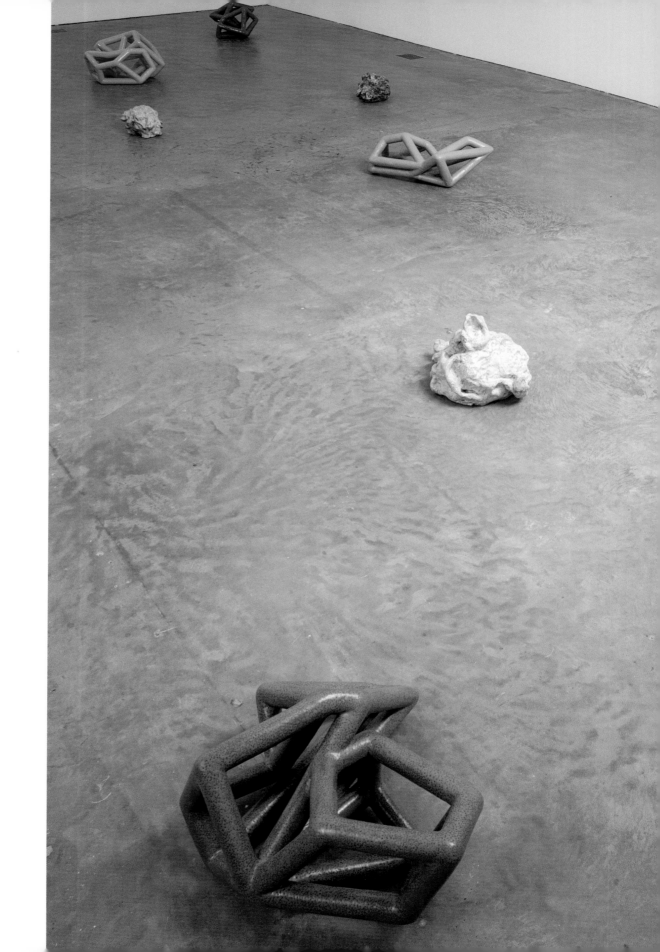

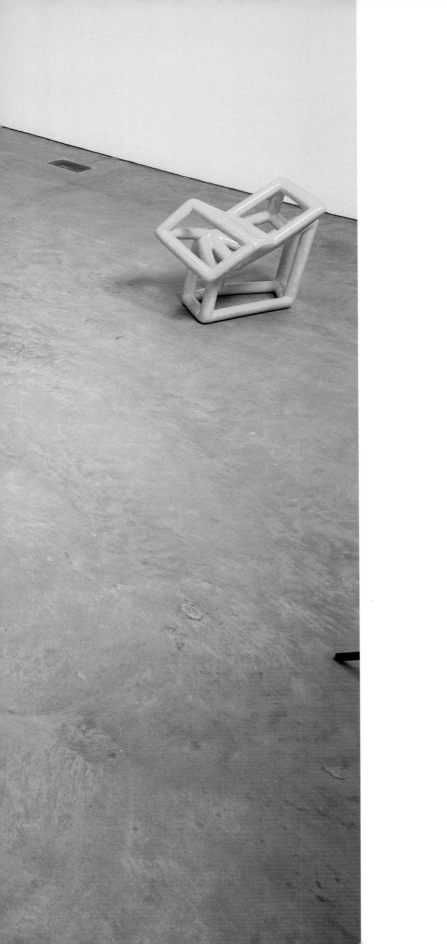

Consequences[1]
Penelope Curtis

fig 1: André Breton, Jacqueline Lamba and Yves Tanguy
Cadavre exquis [Exquisite Corpse], 1938
Scottish National Gallery of Modern Art

SOME DATES

1943

A British doctor and a British pilot meet on the boat
to India.

15 AUGUST 1945

VJ Day: end of hostilities in all theatres of World War II.

15 AUGUST 1947

Independence and Partition of India; the doctor and
the pilot marry and return to Britain.

15 AUGUST 1949

Their second child is born in North Wales.

1955

The child sails down the Suez Canal on the way to
what was then Ceylon, where his father had a new job.
While they waited for their official accommodation to
be ready, they stayed in the town nearby. While they
were there, the small boy saw a snake charmer make a
snake dance and make a tree grow out of a small cone
of sand from under his handkerchief.

1 This essay follows on from one written in
1999, for the second edition of the Phaidon
monograph published in 2000. It is most
specifically based on three recent discussions,
all in London: on 16 October, 13 November
and 22 December, and on a viewing of the
film *Wall of Light* at the Royal Academy.

SOME THINGS

After visiting London to see the Coronation the boy's mother gives him a Coronation Stamp Album and some stamps, some of which had belonged to her, and some to her father, who had been a cotton trader working out of Liverpool. The boy began collecting stamps with more than just enthusiasm. He kept on sticking stamps into the album until he left school, and even now, he still likes stamps.

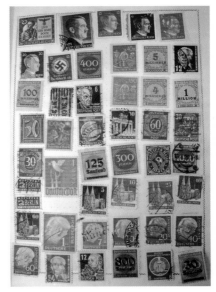

fig 2: Stamps are divided into countries and into years

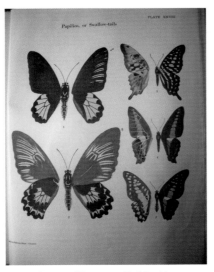

fig 3: Butterflies are divided into species and sub-species.

In Sri Lanka the boy's father gives him *The Butterfly Fauna of Ceylon*. The boy learns to catch and classify his finds, using his book for identification. Although he was only little, the boy was good at catching butterflies, and good at identifying them correctly.

As he grew up, the boy found that some places moved, and some places stayed the same. The sands of Abersoch were not so shifting, when the family returned there on holiday from their various homes in Scotland, England, Sri Lanka and elsewhere. As the family moved, some objects disappeared from his parents' home, and some reappeared, among them photographs of aeroplanes among the clouds, and two German nudes.

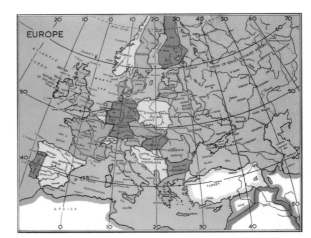

fig 4: Some countries change their name and some their shape

DATES AND THINGS

Over the last few years objects have taken on an increased significance in this man's life. His father has died and, though he has had children of his own, his marriage has ended and he has left the family home. He has not only taken his inheritance, but also taken on the family archive, and with it the family tree. He has sorted out the maternals from the paternals, the Bullivants from the Winstanleys, the cooks from the policemen. He has his parents' photographs, and he is filling in the gaps in their legends.

As this man is an artist, his father left him the pictures. He got a painting of Sri Lanka, the aeroplanes in the clouds, and the two German nudes: Gretel and Eva. He also got a clock, some glass, and two tables. Among the objects he really likes are the souvenirs of other countries which seemed always to travel with the family, and the things which belonged to his Abersoch grandmother (the widow of the cotton trader), such as a wooden elephant.

This man has always collected, but now the objects are all together. He had already separated out his own things from the family home, and now objects that were in his parental home have joined them. And he has returned to collecting with a new passion. As the objects have gathered pace – unrestrained, perhaps, by any external force – so they have also gained in logic, and the man can return to the museological tendencies of his childhood in his wish to collect more examples. The more individual variations you have, the more they make sense as a whole.

He has collections of stones and shells, skulls and plants. Shoes, baskets, boxes and flints. He has texts carved and painted on different kinds of surface. He has lots of plastic toys. He has miniature dogs: miniature terriers, labradors and sheepdogs. And he has newspapers. He has his father's special collection of newspapers: from 1926 to 2001. From the General Strike to the destruction of the World Trade Center. And the collection includes other dates too, documenting other events, known and unknown, famous and invisible. His father died in 2004, so nothing exceptional, either in the bigger history of the world as his father read it, nor in his father's secluded life in retirement, seems to have happened after 2001. But between 1926 (when his father was 13), and 2001 (when he was 88), nearly 40 important things were recorded in the newspapers which were saved and stored in the Somerset home which every Christmas was transformed by the artist's father into something like a city by night, seen from the air by a pilot.

COLLECTIONS

These newspapers, found hidden away in his father's house and salvaged, reminiscent of a puzzle to be worked out over time, are on display as the first work in Richard Deacon's Ikon exhibition. *In My Father's House* is a strange piece which is both a personal homage and an open work of art. Its combination of hermetic, private, and in some cases, unknowable, criteria for selection are conjoined with Richard Deacon's work as an artist. It is a conceptual art work, based on a system which is both transparent and closed, but with elements of the artist's childhood – including his enthusiasm for collecting – and of his father's knowability and unknowability transformed for the gallery wall. Some newspapers report single events which are clearly of international importance while others record a miscellany, any (or none) of which may have had importance for their collector. The criteria for collection were his father's, but it is Deacon who has chosen to put them on display. And, in a manner characteristic of the artist, it is neither fully public nor fully private, and is not a tribute to a his father, even if he may have been a hero.

This is however an uncharacteristic work for Deacon, looking nothing like any of the work he has made in the last thirty years. It is nonetheless representative in that it – like the other multiple 'collections' of small objects laid out on tables and plinths in this exhibition – speaks quite obviously of Deacon's interest in ordering and arranging. But what such works do this for, or why, is more complex. He says collections 'tell us something about the world', but in the same breath he describes taxonomies as doing nothing to help with interpretation or meaning. So what do these collections (or systems works) tell us?

Formally they point up the slippage between image and material; allowing one to predominate over the other, by turn. Different materials allow an idea to show itself for what it is, as primarily an idea, whether it is realised in clay, in plastic, or in lead. And a skull is a skull, whether of a sheep or a stoat, weathered clean or dirty. Making a collection not only clarifies the dividing line between the idea and its material realisation, but also exposes the set, and the notions of multiplication and (in)finitude.

Collections seem both to be lazy and energetic; reactive and pro-active. Do they tell us new things about the world, or do they simply repeat it? Has Deacon retired behind the theme and its variations? The collection – and the repetition it entails – is part and parcel of Deacon's practice, and it necessarily involves a combination of invention and copy. Copying might be understood as an important part of Deacon's conception of art from an early stage. When he was a schoolboy Deacon knew he was going to go on to do art, and so took A levels in maths and science. Art may

have been 'pissing about' (to use his own description) but it was serious, and it was what he intended to do. He liked the look of machinery, but he didn't have the application to be an engineer. He knew he could copy the look, but he was never the technician. His father and his brother made things work; he remained at one remove. This combination of incompetence and purposefulness which Deacon recognises in himself is the licence to make non-functional works which nevertheless have a value.

In his final year at school Deacon took art and physics. In physics he spent his time studying the way polarised filters revealed the stress patterns in plastics. This sounds remarkably like one of the art works that was to come, but at the time there was no tangible overlap between his two subjects. Was he as good at physics as he was at art? Not really; he failed the exam. And how was he good at art? Not with his hands. He was good at asking questions. However, asking questions – messing about, pissing around – is not, in Deacon's eyes, to be equated with experimenting. So despite the intellectual basis to his art, and despite its evident overlaps with science and technology, these works are not seen as experiments by their author.

Experiments may be conducted in series, with more and less successful outcomes, with an elegance in their final solution, but they are not, for Deacon, a helpful way of thinking about art. If his students put forward new pieces of work and describe them as experiments he resents their evasion, finding it hard if not impossible to evaluate their work on that basis. And yet, and yet....his work seems to have so much in common with the conditions set up to evaluate a premise: a set of rules, certain materials, certain approaches to making one component and joining it to the next, defined ways of working with others. But they are not experiments, in Deacon's eyes, because they have no hypothesis. They end when he wants them to end, and not when they have delivered a perfect proof. He decides when a work is a work, and the works are his. This purposeful, almost wilful, authorship is perhaps more than ever a key to understanding what lies behind Deacon's sculpture.

CONNECTIONS

Deacon has been good – in a relatively modest way – at bringing things and people together. Other people add the unknown element; messing about is much easier to do with a friend. A lot of his work operates on the 'what if...?' basis, but for this to operate meaningfully, it is ultimately up to him to decide when enough has been achieved. He may want to adopt different personae, but he never really wants to lose himself. It is for this reason that, although he has worked with a number of skilled craftspeople, he has remained separate from the craft. Another probable

reason is that the fabrication does not retain sufficient interest for him, and thus he never becomes fully skilled in any one particular craft. He uses people to keep things fresh, but stops when he gets bored. So, though Deacon is thought of primarily through the materials and techniques which he manipulates, he stresses the need to remain at one remove, so as to objectify the quality of interest in what is happening. Moreover, his pushing of materials to their limits is perhaps inherently uncraftmanslike; there is even an element of perversity – or cruelty – about some of his material treatments. There is a strange tension in this position; one which has manifested itself on occasion with the colleagues who have gone on to develop the skills which were initially demanded by new types of sculpture. It is they – and principally Matt Perry who steams and shapes and joins the wood for Deacon's sculptures – who make Deacon's sculptures possible. But it is Deacon who provides the space, or the imprimatur, which makes them possible at all.

Deacon has never worked at anywhere near the rate, or with anywhere near the workforce, of famous contemporaries such as Tony Cragg, but his practice is nevertheless characterised by its collaborative nature. The fact that he has kept his practice small, and has himself been intimately invoved in what is often one-to-one dialogue with a given collaborator, has probably exacerbated the tensions of partnership. But it is this steady, even persistent, working dialogue which has engendered the combinations of materials and techniques, and allowed remarkable forms to develop as if they had always been there. Other people add the element of surprise, whether that surprise is 'blind' – like the game of Consequences – or more simply an unexpected interpretation or response. This making new forms from old, or old forms from new, has an interesting relationship to traditional workshop practice and to pre-industrial technique. Deacon puts tried and tested craft techniques together with a new idea, or vice versa, to create combinations which live as whole individuals. And when he has worked with other named artists – Thomas Schütte, or Bill Woodrow – he has often been surprised by the unity of some of the better works despite their dual authorship.

Joining is at the heart of Deacon's work. He joins materials, and makers, and forms.[2] Then he adds titles, which might be either seen as a further ingredient, or as the frame which holds the work together. Their cleverness may conceal what they have been designed to indicate. For coupling runs so centrally though Deacon's oeuvre, and some titles (*Between The Two Of Us*, *Just Us*, *One Is Asleep*, *One Is Awake*, *Nobody Here But Us*) make such a point of saying so, that it seems surprising to me that it and its sexuality is hardly acknowledged. Do we see it but put it to one side? Or is it not that evident in the works themselves? From the *Art For Other People*, which had a clearly fetishistic aspect, through to *Slippery When Wet*, with its almost

2 Deacon's interest in jointing is part of what he has elsewhere described as 'belt and braces': making more than obvious, more than necessary, the way things are held together. I was reminded of this seeing him in the above film in Pierre Chareau's historic *Maison de Verre*, clasping girders and bolts, wondering at the construction site that was the bespoke house. Such a site, funded by a single wealthy patron, becomes a cross between a workshop and a product: a place where solutions were created for problems as they arose.

lewd title, what are we being asked to think (and not thinking)? Touch is important, Deacon readily admits, and speaks specifically of close touch and distant touch. It is perhaps easier to touch sculptures than other people. But we have to go beyond the haptic. So many of these sculptures are composed of two parts, and so many are couples: juxtaposed, conjoined, penetrated.

PERSONALS

Deacon will – if reluctantly – speak of his sexuality in relation to the work, although his primary objection is the problematic relationship of autobiography to art. If he explains that private impeti may only appear evident in later years, this may appear evasive, but he is nevertheless quite ready now to link the tranquillity of his early married life, or the pleasure of fatherhood, to certain tendencies and time-spans in his work. But even if a private event is an impetus, Deacon argues that it cannot be translated into the meaning of the work. And there are no clear corollaries: his recent rather dislocated life-style has resulted in an unusually productive period in which it has been important for him to have something to value.

Though Deacon skates around the edges of personal encounters, and worries about observing and interpreting the boundaries, he likes this uneasiness and doesn't wish that the sexual overture was necessarily any more straightforward. Relationships are about meeting and not meeting; about different kinds of touching. And titles are not just clever (as we always knew) but also personal: *Individual*, *Couple* or *Restless* are not just formal appellations, and a more biographical reading lends a more figurative aspect to the sculptures. Like Deacon's sculpture, sex is overt and covert, elegant and clumsy. So: Deacon does not demur from the sexualised nature of his work, and its relevance to the relationship of one to another. Indeed: sculpture can affirm his sexuality in a simple direct manner and can even be more fully reciprocal than other relationships – with people or with society more generally – which largely seem overly reticent. But the work is as much a way of hiding the autobiographical as revealing it, or as much a way of dealing with life as dealing with life.

Personals is the title of an exhibition which is not obviously personal. And indeed, the 'Personals' section of a newspaper, as Deacon points out, is not that personal. Such ads may want everything but tell you nothing. The newspapers yes, they're his father's, but either the events are so public they belong to all of us, or so obscure that we don't even know how to identify or assess them. Alongside the newspapers is the current range of work: some drawings, some ceramics and a bent wood piece.[3] And here too we have collections. *Alphabet* only became an alphabet when

3 Deacon is concurrently making (or is having made) stainless steel pieces, transposed from photographs of the ceramics, but more molecular (or more sausage-like) in appearance, and steel works which revisit the work he made in PS1 in New York.

24 drawings threatened to become 26; the *Siamese* family shows different ways in which two similar forms might share a confined space; the wrapped ceramic forms manifest different ways of wrapping a void with a plane. *It's A Small World* groups together hundred of small clay models across a table; *Display Table* shows off five found and mounted objects against the unreal space of the plinth.

How would we describe the appearance of these works, and what would they tell us? The tentative drawings which fluctuate between two dimensions and three? The almost repellent plasticy sheen of the *Siamese* ceramics, as if only just recently extruded from a sausage machine? He is glazing his surfaces, fusing and overlaying both colour and shine, onto and into the form beneath. He is bringing forms together, still fascinated by jointing and juncture. Closing and opening, pulling lines apart and grouping them together. The closing of the form in the wrapped and glazed parcels? He is folding and forming. Following the cave or the cluster. And the works – like much of that in recent years – continue to hover on the threshold between clumsy and elegant, knowingly or unknowingly. And perhaps their author doesn't care.

Deacon has convenient descriptions for the themes key to the work of the 1980s (perception) and the 1990s (skin and body). Since 2000 we might note an increase in series, in modularity, and in the plinth. If working with clay is firstly about modelling, it is also about carving (in the proper sense of taking material away), and both methods have been important in this period. But over and above these various features there is a recklessness which marks the production as a whole. Working with new materials, new people and in new circumstances to make work which has a high risk value, Deacon fails but also succeeds. He takes risks and makes duds, but in a sense the logic of the production line (slow as it is) saves individual failures from a bigger failure. Their serial element is made manifest in the almost custodian-like manner of the works' presentation: returning to the first collection, Deacon lays out his models like a child's laid out on the table.

But personal museums give you everything and nothing: their real criteria for inclusion obscure even to their curator. There is surely something cautious about collections; they provide cover, for there is safety in numbers. Seriality exposes the logic of production, but also protects the individual object. Collections do a good job of making us think we know more about what is ultimately unknowable. But if collections tend towards the logical, the rigour of the rule-book might favour the freak, and the family can embrace the rogue or orphan child. If art is an enquiry into the ways things are made and the ways they are represented, beauty may ineluctably be only occasional. Much more importantly, the end-product has to have

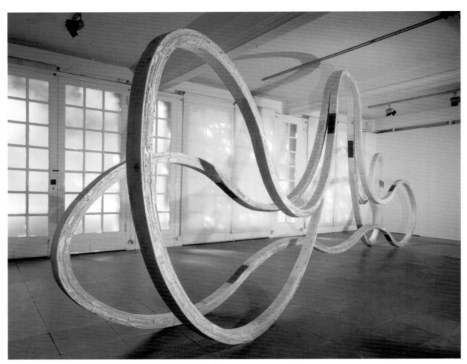

fig 7:
Blind, Deaf And Dumb B,1985
Serpentine Gallery

a self-confidence and a will to live.[4] If a new form is vulnerable, the collection protects it. Deacon has found a way of taking risks and covering his tracks at one and the same time.

PERSONAL AND IMPERSONAL

The series of collages – combining photograph and drawing – which Deacon has been making since the late 1990s are perhaps a little more 'giving' of information than his other work. These graphic works represent the surface between two things, and two different things as well: the plan versus the elevation, the window versus the screen. Framing is important. It is perhaps most obvious in these collages where the sky is like the frame – fixed but floating, in our world, but without scale. Different ways of seeing, and different representations of those different modes, are set against each other, joined – but only roughly (and indeed the holes are cut into the photographs in a rough and ready way which makes them all the more assertive [fig.5]). Deacon is setting one world against another – his world, perhaps, against a outside world, or an interior world against the exterior. The seamless whole of some of the earlier works is gone: instead we here have exposed the joints and seams, the uncomfortable but fascinating realities which rub against each other and refuse to settle.

Fig 6: External view of glazed wall of *Maison de Verre*, Paris, 1928

In 1985 Richard Deacon participated in a film about Pierre Chareau's 1928 *Maison de Verre* in Paris.[5] He was one of the building's interlocutors, along with the architect Richard Rogers. The first part of the film, about the house itself, was supplemented by two complementary features: one on Rogers' Lloyds Building, and the other on Deacon's 1985 project for the Serpentine Gallery. Both Rogers and Deacon were in a sense set up to respond to the translucent (but not transparent) dimpled glass skin of Chareau's façade. Deacon talked of that famous façade as a kind of mirror of transposition, and as I watched the film I began to see it helping his work to coalesce about a screen which allowed things to shift in scale and material. There is a break – a disjuncture – in Deacon's vision (as I picture it), between the internal imagination and the external continuous real world. [fig.6]

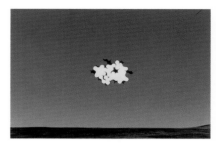

fig 5: **Caithness 5**, 1999

The way we perceive things is understood by Deacon as a physical act, in contrast to the way we imagine things, which he sees as an act of conception. At the Serpentine Deacon first used the blind façade – more like a memory of a window than a window itself – as a screen about which to transpose what might be seen as two sides of the same sculpture, A and B, outside and inside.[6] [fig.7] And for a later project – made for the same gallery twelve years on[7] – he went further, so that the model trees which had earlier served to represent the gallery's garden at a suitably reduced scale now became the very components of a sculpture set at the front of the lawn, small in actuality and far from the gallery's window. This was like a dream, or a memory, of the trees, set among the real trees themselves. [fig.8]

The dream world of Pierre Chareau – in which glass gives light but no vision – seems to have deeply affected Deacon in his subsequent plays of dislocated images, placed on screens, obscuring vision while at the same time drawing attention to the view beyond. Meshed windows charm but obfuscate; the distant view tantalises but becomes more invisible as the viewer draws nearer. Deacon's dimpled clouds, first set at odds against the windows in his 1991 installation in Mies van der Rohe's houses at Krefeld, and later realised as the wall sculptures *Infinities*, [fig.9] pull us back to Chareau's tessellated glazing bricks and take us forward to the artist's interest more generally in pierced screens and in forms floating free, unanchored, in space.

4 This is why Deacon doesn't like his students talking of their work as experiments.

5 *Wall of Light*, by John Tchalenko, was first shown on Channel 4 in 1986

6 *Blind, Deaf And Dumb*, A and B, both 1985

7 *One, Two, Tree* at the Serpentine Gallery, 1997

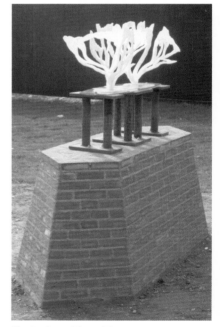

fig 8: **One, Two, Tree**, 1997
Serpentine Gallery

GIVE AND TAKE
The picture stuck to the pane, the cloud seen through the plane window. Deacon uses the window-screen like a lens which makes things smaller or larger. Things are at different registers, different ranges, and though we may see them together all the time, we are not used to seeing them shown together. Deacon's screens are

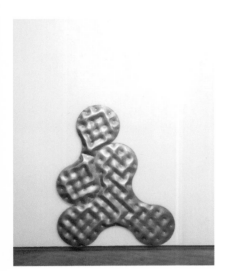

fig 9: **Infinity No 4**, 1999

like seams; rarely continuous but rather blocking views or exposing discontinuities. His mirror on the world exposes its joints, and stamps one vision (his) against another (the wider world). Whereas earlier sculptures may have joined things together in a more or less cohesive way, Deacon's newer work is often more about the impermanence of the join. The fit may be good, but it is often difficult. Deacon joins things which may not want to be joined, finding ways of keeping them together, more or less against their will, more or less because of his. The resulting forms are more earthly, and more earth-bound; gone is the assured ethereality of the early work, in its place something more obviously problematic. Such joins are all about us: the way we relate to others and to the world around us. In this sense it could be said that, in falling to earth, Deacon's work has become more human.

In *Personals* Deacon tells us no more about himself than he ever has before, but he somehow allows us to ask the question. What is personal to this sculptor? What does he bring with him? What does he do with his embrace of the world and the way it is put together, with his collections and his travels? What does he (what do we) make of his fondness for information and the way it is organised: for stamps, atlases, samples and species? What does it mean for him to make collections, of other people's things and of his own? How does he go beyond the minutiae to make something bigger, and to make something new? Deacon still has something of the clever boy who liked to learn how the world was organised, and then to make a contribution which both drew from that order and refused it. The question which asks what Deacon's work is about is hard to answer. The question about why, or how, it happens, is easier. It happens because his status is sufficient to give him a lot of licence, and because of his determination, and because of his curiosity.

It's A Small World, 1999 – 2005
Table with 130 small clay sculptures
95 x 320 x 227 cm

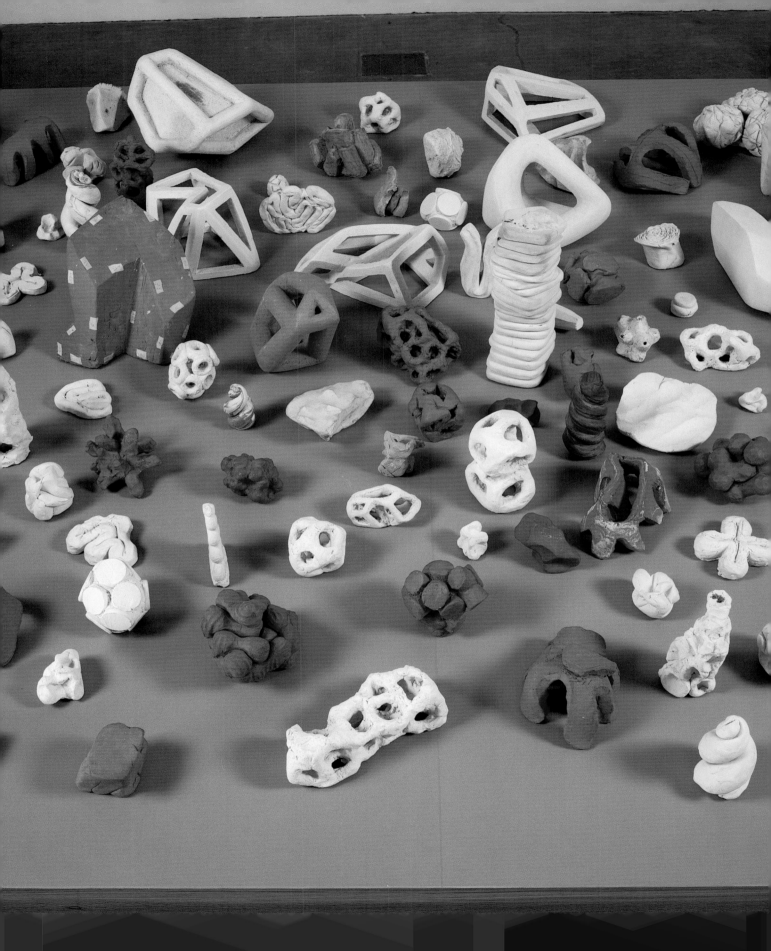

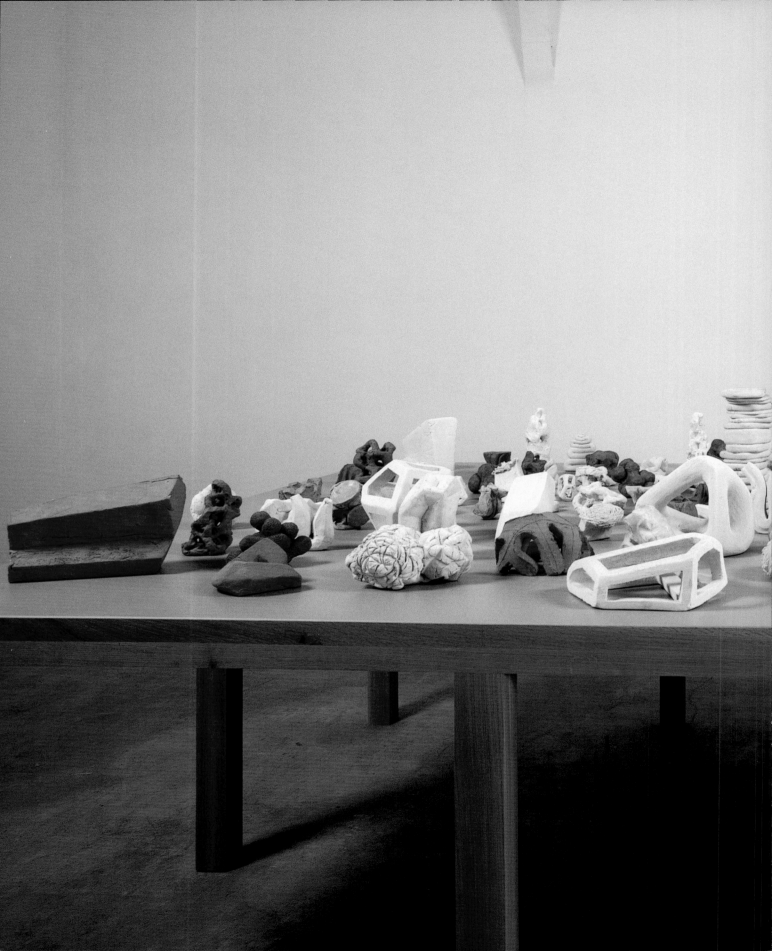

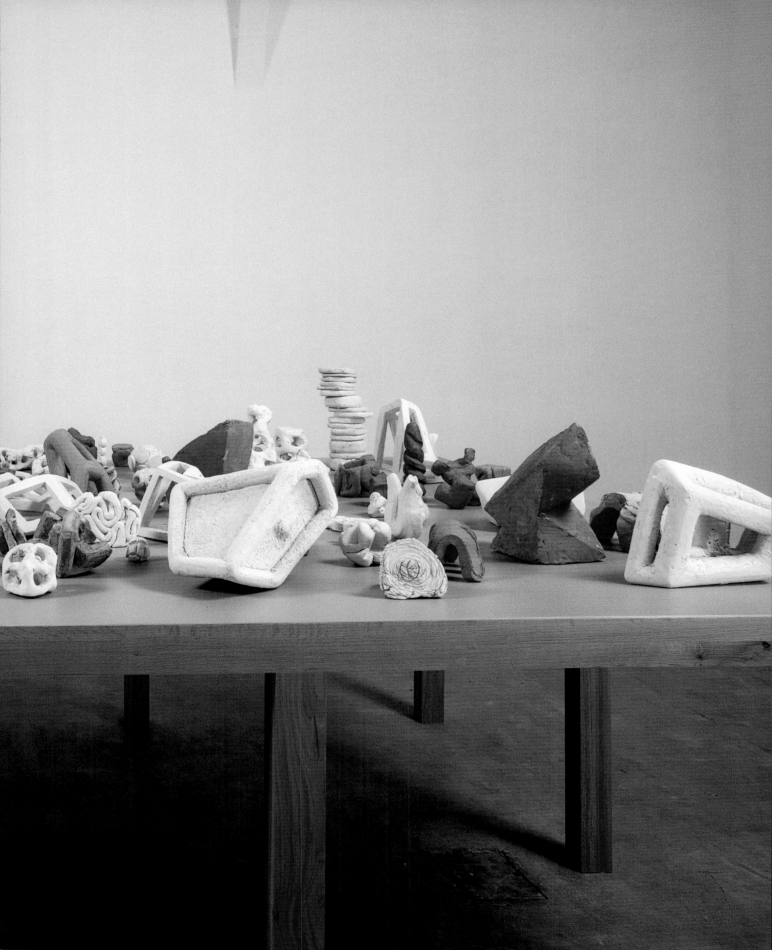

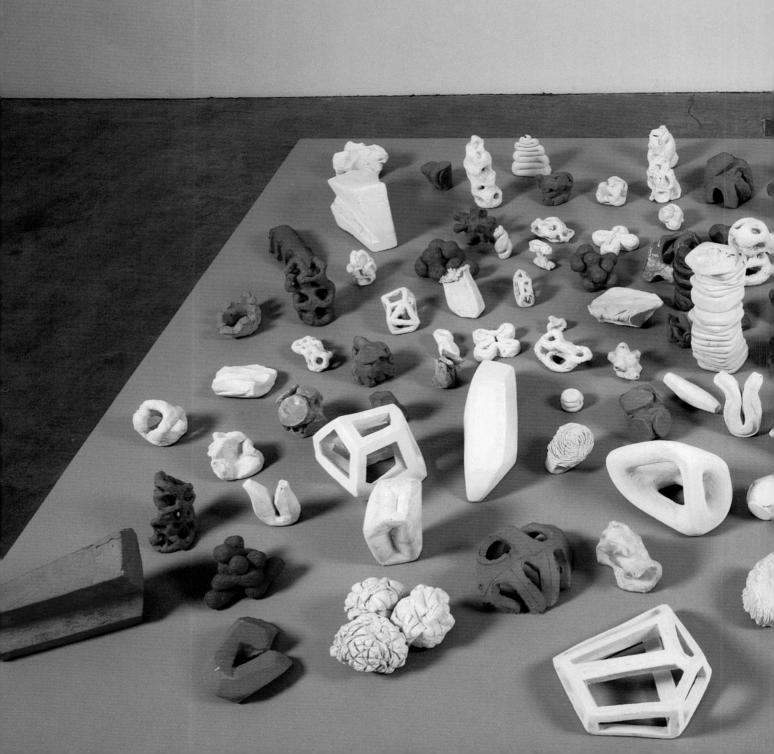

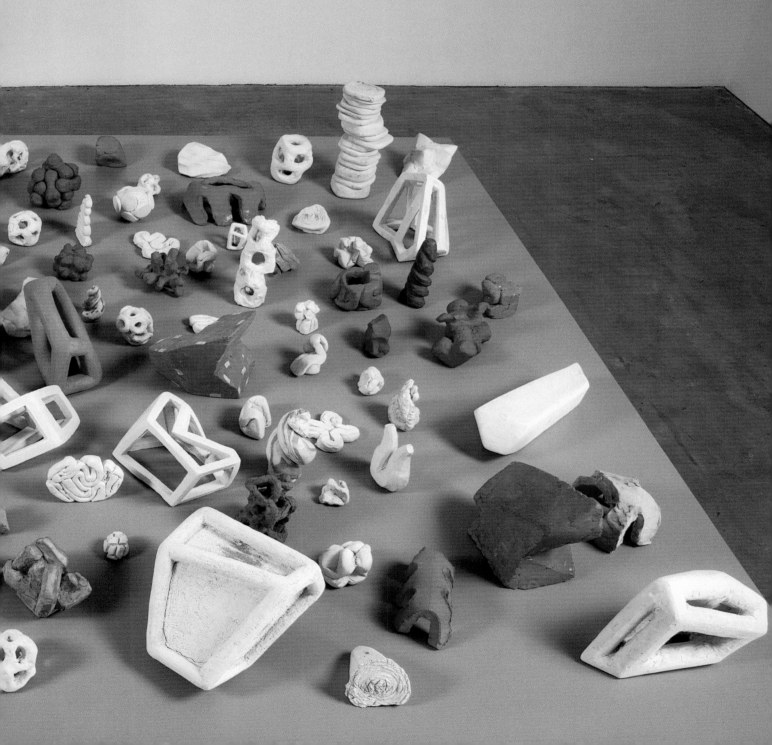

Alphabet, 2004–05
Graphite on paper
36.5 x 43.5 cm (x 26)

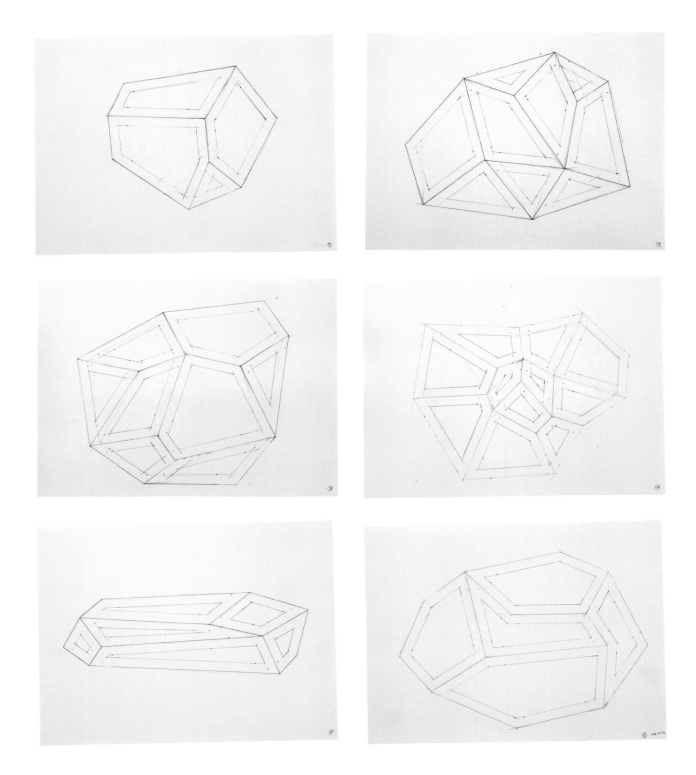

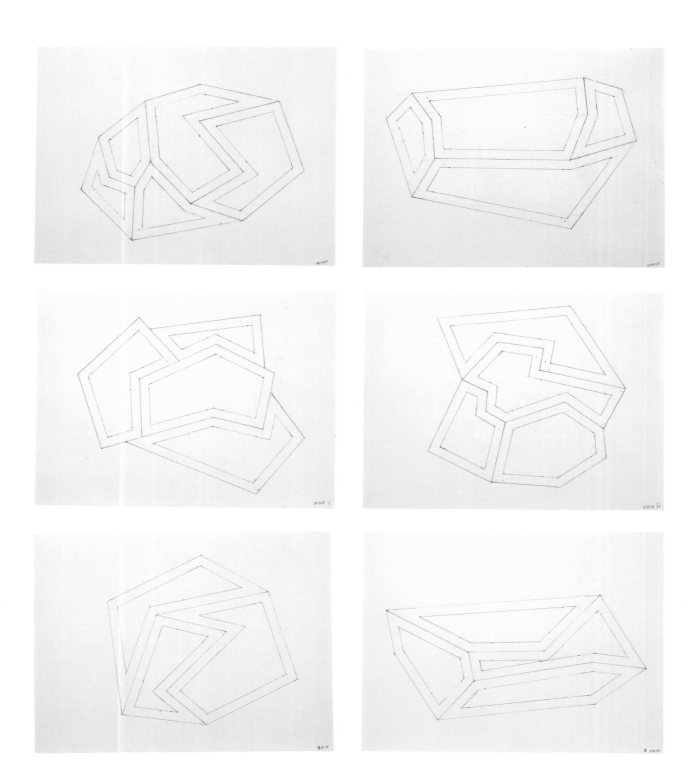

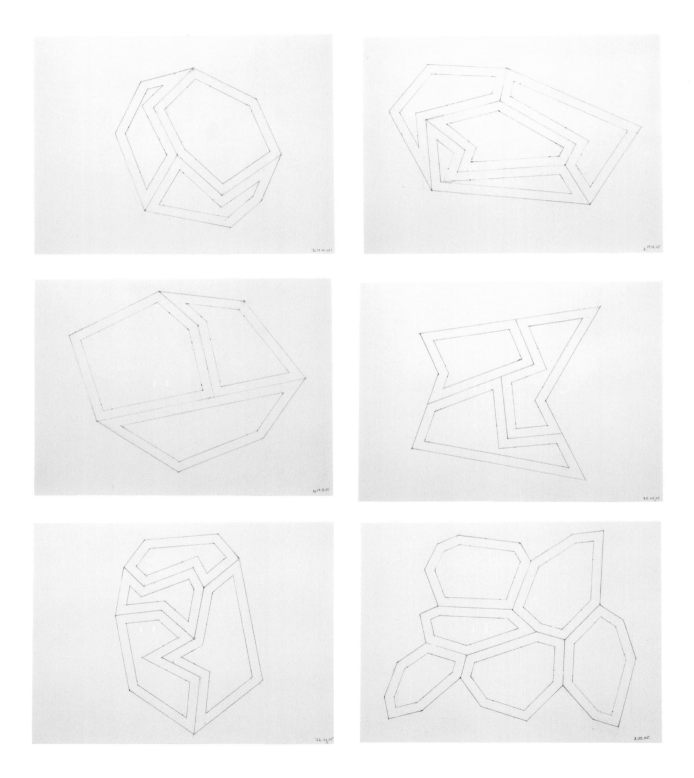

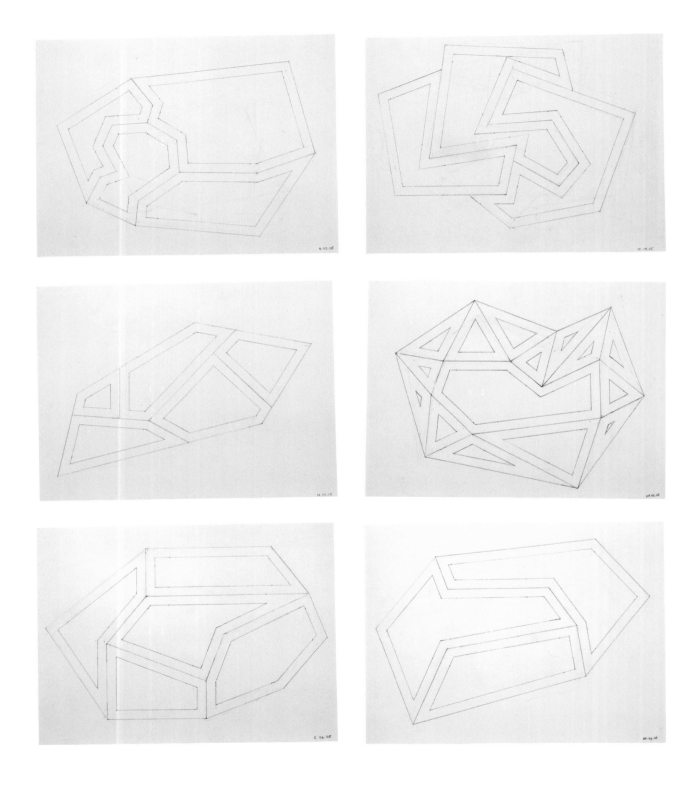

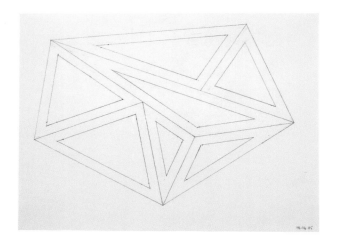

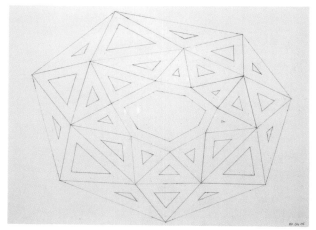

Out Of Order, 2003
Wood and stainless steel
190 x 700 x 570 cm

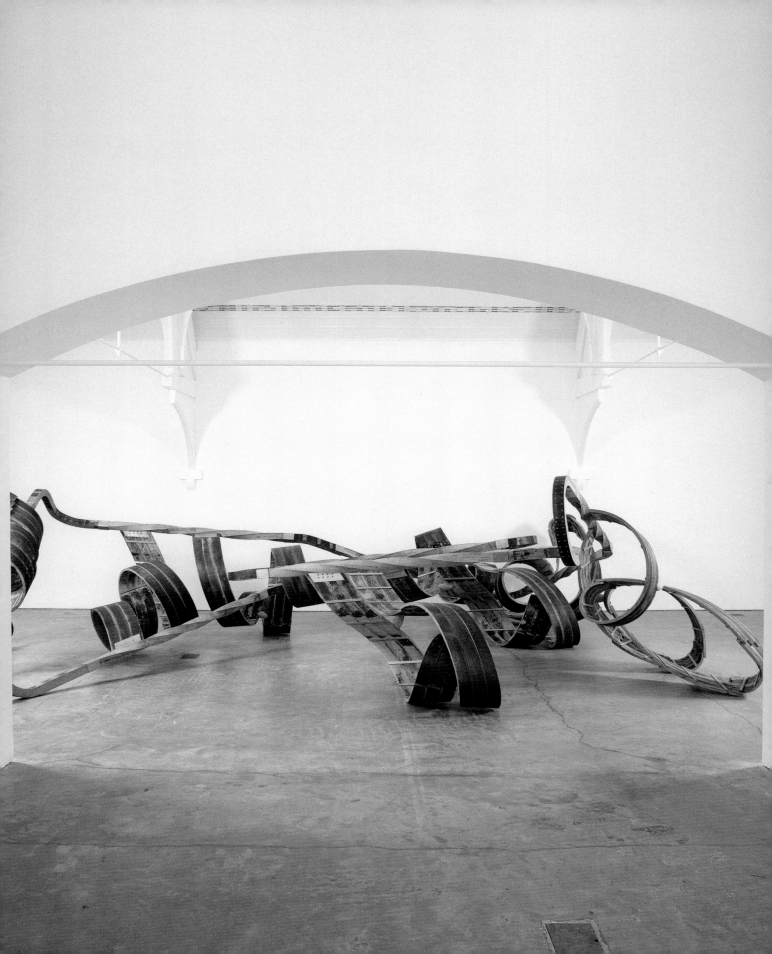

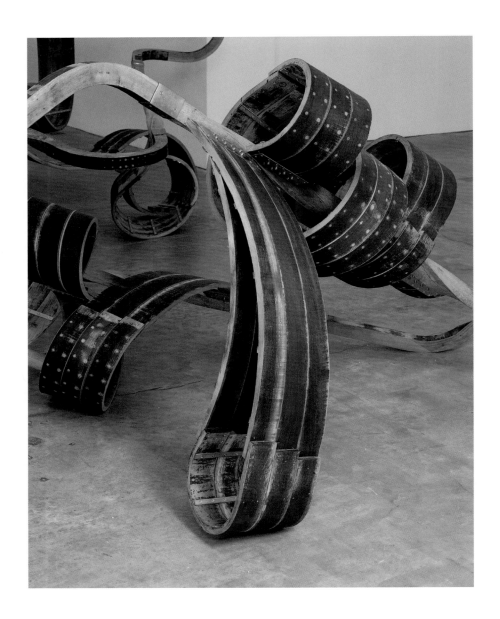

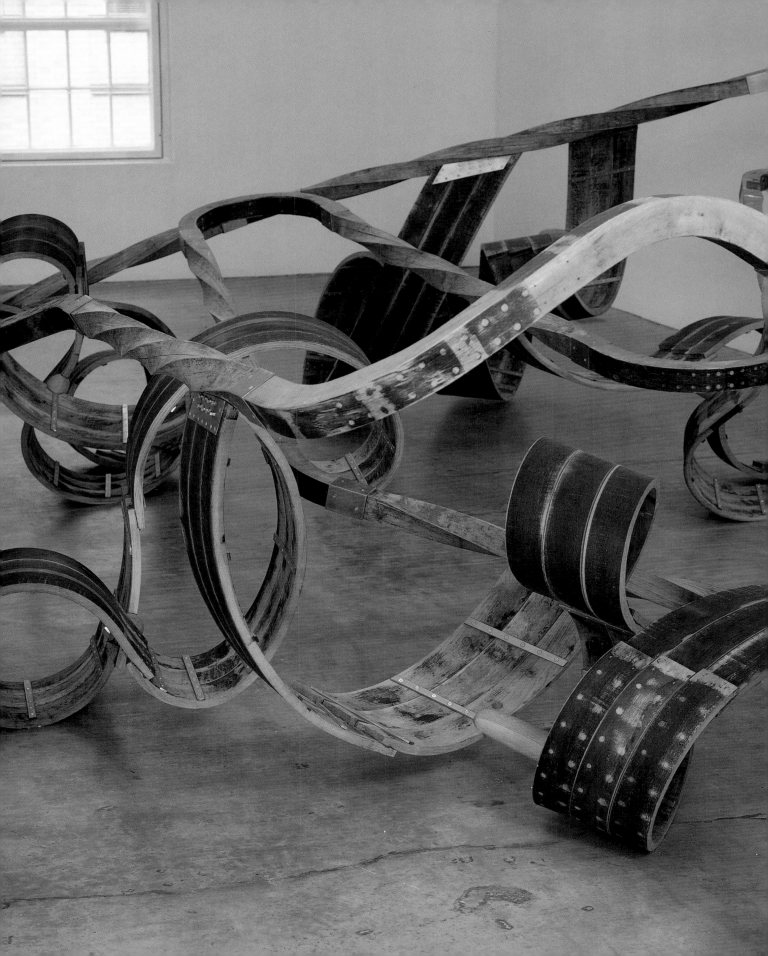

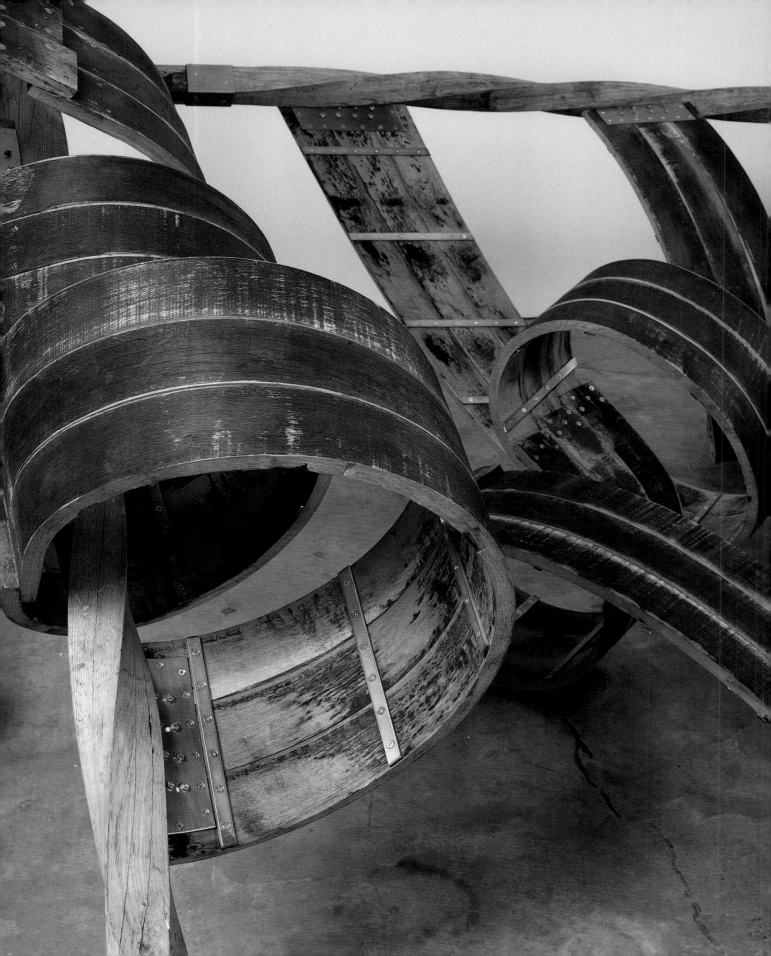

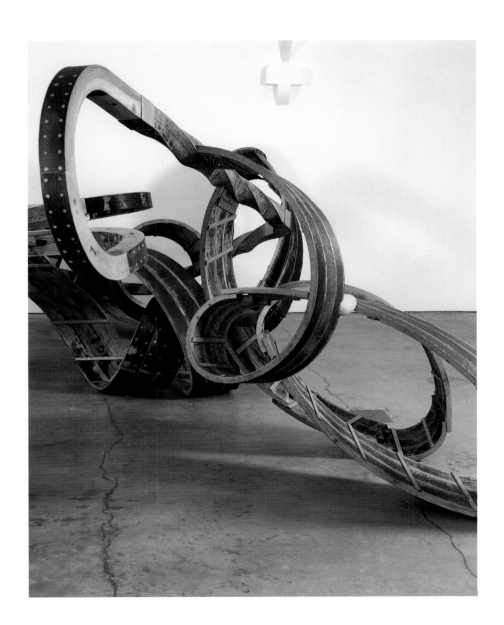

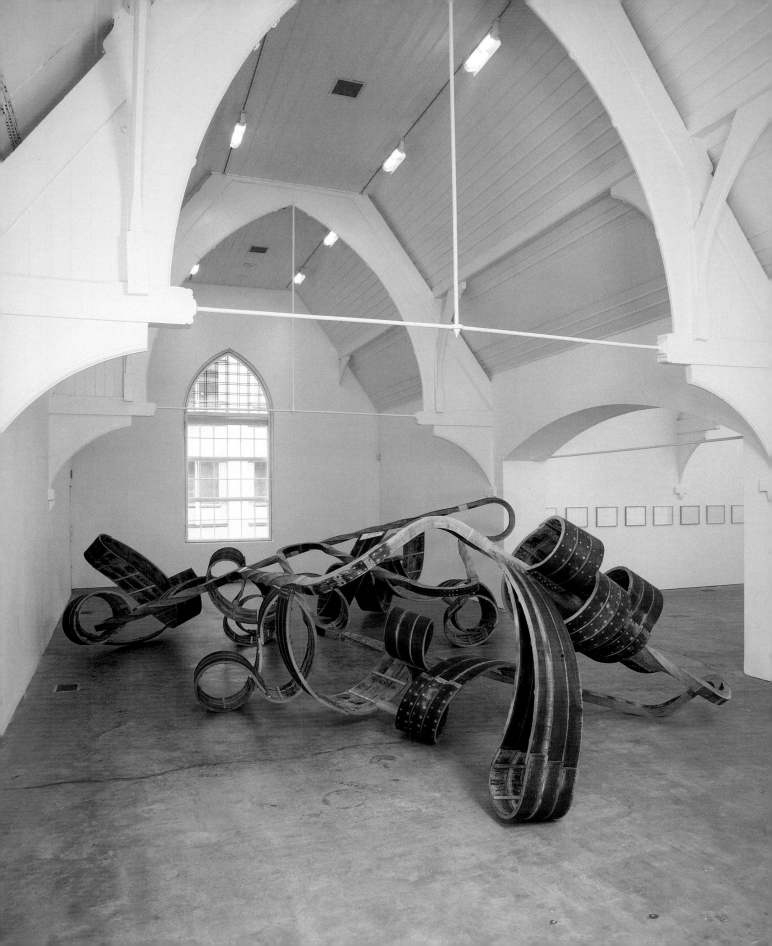

Biography

1949
Born Bangor, Wales

1968–69
Somerset College of Art, Taunton

1969–72
St Martins School of Art, London

1974–77
Royal College of Art, London

1977–78
Chelsea School of Art, London (part-time)

1987
Awarded Turner Prize, London

1999–DATE
Professor, Ecole Nationale Superieure des Beaux Arts, Paris

One Person Exhibitions

1980
Spring Programme, The Gallery, London

1983
Lisson Gallery, London
The Orchard Gallery, Londonderry*

1984
Riverside Studios, London
Richard Deacon. Sculpture 1980–1984, Fruitmarket Gallery,
Edinburgh; Le Nouveau Musée, Lyon/Villeurbanne*

1985
*Blind, Deaf and Dumb. An Installation in Collaboration with
Richard Rogers and John Tchalenko*, Serpentine Gallery, London

1986
Marian Goodman Gallery, New York

1987
For Those Who Have Eyes. Richard Deacon Sculptures 1980–86,
Aberystwyth Arts Centre, Wales; Glynn Vivian Gallery,
Swansea; Turner House, National Museum of Wales; Mostyn
Art Gallery, Llandudno; Warwick Art Centre; City Museum
and Art Gallery, Stoke on Trent*
Lisson Gallery, London

1987–88
Richard Deacon. Recent Sculpture 1985–1987, Bonnefanten
Museum, Maastricht; Kunstmuseum, Luzern; Fundaçion Caja
de Pensiones, Madrid and Museum van Hedendaagse Kunst
Antwerpen*

1988
Marian Goodman Gallery, New York*
The Carnegie Museum of Art, Pittsburgh, Pennsylvania;
The Museum of Contemporary Art, Los Angeles and
Art Gallery of Ontario, Toronto*

1989–90
Whitechapel Art Gallery, London*

1989
Richard Deacon. 10 sculptures 1987–89, Musée d'art moderne de
la Ville de Paris, Paris*

1990
Richard Deacon. Nye Arbeider/New Works, Kunstnernes Hus,
Oslo‡

1991
Drawings 1974–91, Mead Gallery, University of Warwick,
Coventry*
Skulpturen und Zeichnungen, Museum Haus Lange und Museum
Haus Esters, Krefeld*

1992
Foursome, Lisson Gallery, London
Art For Other People, Musée d'art moderne, Villeneuve d'Ascq*
Marian Goodman Gallery, New York
(With Bill Woodrow) *Only the Lonely and other Shared Sculptures*,
Chisenhale Gallery, London; Aspex Gallery, Portsmouth*
Skulpturen 1987–1993, Kunstverein Hannover*

1995
L.A. Louver Gallery, Los Angeles
(With Thomas Schütte) *Them and Us*, Lisson Gallery, London

1996–97
Richard Deacon, Esculturas 1984–95, MACCSI, Caracas, Venezuela;
Wilfredo Lam Arts Centre, Havana, Cuba; Museo de Arte
Moderna, Bogota, Colombia; Museo Nacional des Bellas
Artes, Santiago de Chile; Tamayo Museum, Mexico*

1997
Marian Goodman Gallery, New York
Richard Deacon, Show and Tell, Musée Departemental de
Rochechouart, Haute-Vienne, France

1999
New World Order, Tate Gallery, Liverpool*
Lisson Gallery, London

2000
Umhh, Fig 1, London

2001
Richard Deacon: Sculpture Dundee Contemporary Arts*
(With Philip Lindley, co-curator) *Image & Idol-Medieval
Sculpture*, Tate Britain, London*
(With Henk Visch) *Between the Two of Us*, Stedelijk Museum,
Schiedam, Netherlands*

2002
Lisson Gallery, London
Richard Deacon: Continent, Galerie Arlogos, Paris
AC: Richard Deacon Made in Cologne, Museum Ludwig, Cologne*
Richard Deacon, Passage de la mer rouge, Centre Pompidou, Paris

2004
(With Bill Woodrow) *Lead Astray: New Shared Sculptures by Bill
Woodrow & Richard Deacon* New Art Centre Sculpture Park &
Gallery, Roche Court, Salisbury, Palacio Nacional de Quelez,
Lisbon, Yorkshire Sculpture Park), Wakefield, (2006); City
Museum & Art Gallery, Plymouth, (2006); Musée du Chateau,
Dieppe (2007)*
Richard Deacon Marian Goodman Gallery, New York

2005
Richard Deacon: Out of Order, Tate St Ives, Cornwall*
The Size of It, Museo Artium, Vitoria, Spain; Sara Hilden Art
Museum, Finland; ARP Museum Bahnhof Rolandseck,
Germany*
Richard Deacon, Range, Lisson Gallery, London

2007
Richard Deacon, Personals, Ikon Gallery, Birmingham, UK*
Welsh Pavilion, 52nd Venice Biennale

PUBLIC COMMISSIONS

1990
Between The Eyes, Yonge Square International Plaza, No 1 Yonge
Street, Toronto
Once Upon A Time, Former Redheugh Bridge Abutment,
Gateshead, UK
Moor, Victoria Park, Plymouth, UK

1991
Let's Not Be Stupid, Former Air Hall Site, University of Warwick,
Coventry, UK
Nobody Here But Us, Office Tower Plaza, 135 Albert Street,
Auckland

1992
Building From The Inside, Voltaplatz, Krefeld, Germany
Between Fiction And Fact, Musée d'art Moderne, Villeneuve
d'Ascq, France
This Is Not A Story, Museum der Stadt, Waiblingen, Germany
One Step, Two Step, Landspitze and Nieuwmarkt, Nordhorn,
Germany

1993
Zeitweise, Mexicoplatz, Vienna

1996
One Is Asleep, One Is Awake, The Tokyo International Forum,
Tokyo
Gates & Railings, Custom House Arts Centre, South Shields,
UK

1999
No Stone Unturned, Bemalter Stahl Platz, Liestal, Switzerland

2000
Just Us, Cosco Building, Fuxingmei Street, Beijing
Can't See The Wood For The Trees, A9/N22 Neupunkt, Haarlem,
Netherlands

2003
Not Out Of The Woods Yet, 1st & Howard, San Francisco

2006
Mountain, Tsumari, Niigata, Japan
The Same But Different, N381 Hoogesmilde and Emmen,
Netherlands

GROUP EXHIBITIONS

1970
(With C Walters and I Kirkwood) New Arts Lab, London

1974
(With Manydeed Group) Artists' Meeting Place, London

1981
*Objects and Sculpture: Richard Deacon, Antony Gormley, Anish
Kapoor, Peter Randall-Page*, Institute of Contemporary Art,
London; Arnolfini Gallery, Bristol*

1982

Englische Plastik Heute/British Sculpture Now, Kunstmuseum, Luzern, Switzerland*

1983

Transformations: New Sculpture From Britain, XVII Biennal de São Paulo; Museo de Arte Moderna, Rio de Janeiro; Museo de Arte Moderna, Mexico; Fundaçao Calouste Gulbenkien, Lisbon*

1984

An International Survey of Recent Painting and Sculpture, Museum of Modern Art, New York*

Skulptur im 20 Jahrhundert, Merian Park, Basel*

1985

1985 Carnegie International, Carnegie Museum of Art, Carnegie Institute, Pittsburgh*

1986

Entre el Objeto y la Imagen. Escultura britanica contemporanea, Palacio Velasquez, Madrid and Fundacion Caja de Pensiones, Barcelona*

Sonsbeek 1986. International Sculpture Exhibition, Arnhem, The Netherlands*

Prospect 86. Eine internationale Austellung aktueller Kunst, Frankfurter Kunstverein, Frankfurt *

Correspondentie Europa, Stedelijk Museum, Amsterdam*

1987

British Sculpture Since 1965, Museum of Contemporary Art, Chicago and San Francisco Museum of Modern Art; Newport Harbour Art Museum, Newport Beach, California; Hirshhorn Museum, Washington; Albright-Knox Art Gallery, Buffalo*

Juxtapositions: Recent Sculpture from England and Germany, PSI, The Institute for Art and Urban Resources Inc, New York*

Skulptur Projekte in Munster, Munster*

1988

From the Southern Cross, The Biennale of Sydney*

1990

Frank Auerbach, Lucian Freud, Richard Deacon, The Saatchi Collection, London*

New Works for Different Places: Four Cities Project; Orchard Gallery, Derry; Third Eye Centre, Glasgow; Projects UK, Newcastle; Plymouth Arts Centre*

1991–92

Carnegie International 1991, The Carnegie Museum of Art, Pittsburgh*

Documenta IX, Kassel*

Platzverführung, Museum der Stadt, Waiblingen, Germany*

1995

Ars 95, Helsinki*

1996

Un siècle de sculpture anglaise, Jeu de Paume, Paris*

Sarajevo, Moderna Galeria Ljubljana

1997

Material Culture, Hayward Gallery, London *

Skulpturen Projekte 97, Munster*

1998

10 Intensità In Europa, Museo Pecci, Prato

Happiness, Mori Art Museum, Tokyo*

2004

Turning Points: 20th Century British Sculpture. Tehran Museum of Contemporary Art, Tehran*

Days Like These, Tate Britain, London*

2005

Effervescence, la sculpture "anglaise" dans les collections publiques françaises de 1969 à 1989; Musée des Beaux-Arts d'Angers, Angers, France*

Shark, 2003
Glazed ceramic
50 x 175 x 40 cm

Richard Deacon *Personals*
Ikon Gallery
31 January – 18 March 2007

Curated by Jonathan Watkins, assisted by Diana Stevenson

ISBN 978 1 904864 30 1

Ikon Gallery
1 Oozells Square, Brindleyplace, Birmingham, B1 2HS
t: +44 (0) 121 248 0708 f: +44 (0) 121 248 0709
http://www.ikon-gallery.co.uk
Registered charity no: 528892

Edited by Jonathan Watkins
Text by Penelope Curtis
Designed by Herman Lelie and Stefania Bonelli
Printed by Connekt Colours, UK
Photography by Jerry Hardman-Jones except p. 46 fig 1: courtesy of the Scottish National Gallery of Modern Art; p. 47 figs 2–4: Richard Deacon; p. 54 fig 7: courtesy of Richard Deacon and Lisson Gallery; fig 6: Michael Halberstadt, arcaid.co.uk; p. 55 figs 5 and 8: courtesy of Richard Deacon and Lisson Gallery; p. 56 fig 9: courtesy of Richard Deacon and Lisson Gallery

Distributed by Cornerhouse Publications
70 Oxford Street, Manchester, M1 5NH
publications@cornerhouse.org
t: +44 (0)161 200 1503 f: +44 (0)161 200 1504

All works courtesy of the artist, Marian Goodman Gallery, New York and Lisson Gallery, London. Those reproduced here, with catalogue details including dimensions, were in the exhibition

Ikon gratefully acknowledges financial assistance from Arts Council England, West Midlands and Birmingham City Council

This exhibition is supported by Brindleyplace, Esmée Fairbairn Foundation, The Henry Moore Foundation and Stanley Thomas Johnson Foundation